M000276053

PROJECT PHOTOSHOP® 7

NAT GERTLER

DEDICATION

This book is dedicated to Brie Gertler, because it's her fault.

—Nat

THOMSON

DELMAR LEARNING™ Australia Canada Mexico Singapore Spain United Kingdom United States

Project Photoshop® 7

by Nat Gertler

Business Unit Executive:
Alar Elken

Developmental Editor:
Jaimie Wetzel

Executive Production Manager:
Mary Ellen Black

Executive Editor:
Sandy Clark

Executive Marketing Manager:
Maura Theriault

Production Manager:
Larry Main

Acquisitions Editor:
James Gish

Marketing Coordinator:
Sarena Douglass

Production Editor:
Tom Stover

Editorial Assistant:
Jaimie Wetzel

Channel Manager:
Fair Huntoon

Cover Design:
May Mantell, Leverage Design

Library of Congress Cataloging-in-Publication Data:

Gertler, Nat.
 Project Photoshop 7 / Nat Gertler.
 p.cm.
 ISBN 1-4018-2589-3
 1. Computer graphics. 2. Adobe Photoshop.
 3. Web sites—Design. I.
Title.
T385 .G394 2002
006.6'869—dc21
2002012688

CONTENTS

PROJECT 7 DANGEROUS METAL PIPE55

Using the grid • Transforming shapes • Editing shapes • Naming
layers • Duplicating layers • Restacking layers • Creating styles •
Saving styles

PROJECT 8 DOTTY IMAGES .67

Creating action folders • Recording actions • Adding action stops •
Playing actions • Batch processing • Color halftone filter

PROJECT 9 ANIMATED ADVERTISEMENT75

Switching to ImageReady • Animating • Inserting frames • Loading
swatches • Text palette • Turning off visibility

PROJECT 10 A CLOUDY DESIGN87

Designing gradients • Creating work paths • Combining objects
• Stroking • Selections from paths • Airbrush capabilities •
History brush • Art history brush

PROJECT 11 SPOOKY EYES .95

User-created slices • Creating rollovers • Testing rollovers •
Previewing images

PROJECT 12 WEB PAGE MENU105

Layer-based slices • Slice links • Rollover styles • Image mapping

PROJECT 13 CD TRAY CARD .117

Working in CMYK mode • Rulers • Guides • Channels

PROJECT 14 CD INSERT .129

Gamut warnings • Noise filter • Quick Mask mode • Making
and using alpha channels • Lighting effects • Adjustment layers
• Text selection

PROJECT 15 YOUR OWN LETTERHEAD139

Converting text to a shape • Deleting anchor points • Storing a cus-
tom shape • Drawing straight lines • File info • Page setup

PROJECT 16 ADVERTISING POSTCARD151

Custom brushes • Tool presets • Custom patterns • Rotation •
Polygon shapes • Noise gradients • Drop shadows

PROJECT 17 MATCHED MINI MASTERPIECES163

Smudge tool • Texture effects • Brush dynamics • Duplicating an
image • Prerecorded actions • Image flipping

PREFACE

Welcome to *Project: Photoshop 7*. This book will take you step by step through 20 interesting and fun projects you can do with Adobe Photoshop. By the time you've completed these projects, you'll know from experience how to use the program. This book can be used as a stand-alone tutorial, or it can be used as part of a classroom experience.

Adobe Photoshop is a vast and complex graphics tool, with an unspeakably huge number of features and options. This book doesn't explain every single detail of every possible feature. There are books that do try to do that—they're usually the size of a city phonebook (and almost as exciting). Instead, *Project: Photoshop 7* shows you the features you'll probably need, gives you tips about useful and interesting options, and builds in you a larger understanding of how Adobe Photoshop works. With that understanding, you will be well equipped to grasp Photoshop's on-line manual's explanation of any additional features you need.

You don't need a lot of computer experience to use this book. If you know how to use a mouse, and you've used a word processor, a spreadsheet program, or even a music program to create, save, and reopen files, you should be able to follow everything in this book without a problem.

HOW THIS BOOK IS ORGANIZED

There are 20 Photoshop projects in this book. Each project is broken down into one-page procedures that advance the project in some visible way toward completion. If this book were *Project: Lunch*, for example, the first project might be making a peanut butter and jelly sandwich. "Spreading the peanut butter" would be one of the procedures in that project, and that procedure would be broken down into steps ("Open peanut butter jar," "Scoop some peanut butter out of the jar with a knife," "Drag knife across the bread," and so on).

I designed the projects to be performed in order, with earlier projects showing you the most basic features of the program, and later projects demonstrating more complex and subtle uses. Sometimes the later projects reuse things you created in earlier projects (the second project in *Project: Lunch* might be "Packing Your Lunchbox," and one of the steps might be "Take the sandwich you made in Project 1

and stick it in the lunchbox"). You skipped over that project? Don't worry; just use a similar item that you get from somewhere else. (In this book, we're basically recycling computer graphic files, and you can use any similar computer graphic file instead.)

Later projects also presume that you've learned from the earlier ones. If the fourth project is "Make a Peanut Butter, Tuna, and Mustard Hoagie," I'm not going to spend an entire procedure telling you how to spread peanut butter again. Instead, it'll just be a single step: "Spread peanut butter on the roll (as shown in Project 1, Procedure 3)."

THE PROJECTS

Each project begins with a page listing the things you'll need for that project (bread, peanut butter, jelly, knife, plate) and a list of concepts that are taught in that project (spreading, slicing, and so on). In the color section of the book, you'll see pictures of the complete projects in full, glorious color.

THE PROCEDURES

Each procedure has a series of steps. Many of those steps are illustrated with pictures of parts of the program's interface. If you're asked to click a button you haven't used before, I'll show you a picture of the button. If you're asked to select some options on a dialog box, I'll show you a picture of that dialog box (and if it's a complex one, I'll circle the options you need to pay attention to). If a step requires some special mouse movement, you'll see a picture with a highlighted arrow showing you the path for the mouse. The pictures are taken on a Macintosh running OSX, so your screen may look different if you're using Windows or a different Mac OS.

Many of the steps have additional notes.

 Read the *tip* notes that look like this! They show you faster and better ways of doing things.

 Why are there *why* notes, such as this one? To explain why a step is needed, and why it works as it does.

..

A DEEPER UNDERSTANDING: THESE SECTIONS

When you encounter an *a deeper understanding* section, you find a more in-depth explanation of some Photoshop concept. You don't have to read these notes to complete the project at hand, but you probably should read them for educational value.

At the bottom of each procedure's page is a picture of what the project looks like at the end of that procedure, so you can see how you're building to the end result. Please realize that what you see at the bottom of the page is what your image would look like if you printed it after that procedure. It may not match what you see in your image window. For example, if the procedure is about how to zoom in on a portion of your image so you can work on small details, the picture at the bottom will still have the entire image rather than the enlarged portion.

Most of the projects are color images. Check the color section of the book to see the end results in full color!

ABOUT THE AUTHOR

Astronaut, juggler, troubadour, captain of a championship football team—none of these descriptions truly captures the real Nat Gertler. In fact, all are laughably inaccurate, having absolutely nothing to do with Nat.

No, Nat's a writer. He has credits on over a dozen computer books, including *Easy PCs, Multimedia Illustrated,* and *Complete Idiot's Guides* on such topics as MP3s, PowerPoint, and Paint Shop Pro. His non-computer writing credits encompass a wide range of media, everything from slogan buttons to animated TV. He's most at home working in comics, where he has written everything from serious drama to adventures of the Flintstones. His self-published miniseries *The Factor* brought him a nomination for comicdom's coveted Eisner award.

Nat's efforts this year include not only *Project* books on Illustrator 10, QuarkXPress 5, Flash MX, and Dreamweaver MX, but also editing and publishing books on comics writing, writing columns and crossword puzzles for *Hogan's Alley* magazine, programming for the e-Badge.com Web site, running AAUGH.com (a site for fans of books of the Peanuts comic strip), speaking at the Charles M. Schultz museum, performing as a motion picture "extra," and occasionally sleeping.

For more about Nat, check out www.Gertler.com.

THANKS

Thanks to all of the Delmar superheroes who stood behind this book and helped bring forth this new series: the incredible Jim Gish, the thoroughly credible Tom Stover, the nigh-mythical Juanita Brown, the indestructible Jaimie Wetzel, the astounding Melissa Cogswell, and any other members of the team (who must have used their invisibility powers to avoid my detection).

Thanks also to all the dear female Gertlers who helped with this project: Susan, Pocahontas, Lara, and Sarah.

PROJECT I
A TEDDY BEAR

CONCEPTS COVERED

- ❏ Starting an image
- ❏ Picking tools
- ❏ Picking colors
- ❏ Using shape tools
- ❏ Using the paintbrush
- ❏ Saving a file

REQUIREMENTS

- ❏ None

RESULT

- ❏ A simple drawing of a teddy bear head

PROCEDURES

1. Open a new file
2. Get the ellipse drawing tool
3. Pick the bear's fur color
4. Draw the head and ears
5. Get the paintbrush tool
6. Draw the face
7. Save the file

PROCEDURE 1: OPEN A NEW FILE

1. From the **File** menu choose **New.** A dialog box appears.

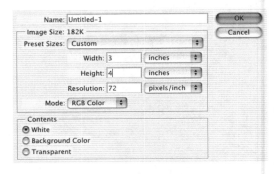

 Next to **New** on the menu you will see a *keyboard shortcut* for starting a new image: ⌘N on the Macintosh, Alt+N on Windows. If you hold down the ⌘ key or **Alt** key and press **n,** a new image opens letting you skip using the menu. Many menu commands have such shortcuts.

2. Next to the **Width** and **Height** fields are drop menus with measurement units. Set both of these fields to **inches.**

3. Enter **3** in the **Width** field and **4** in the **Height** field to set up an image 3 inches × 4 inches.

4. Set the **Resolution** field to 72 and select **pixels/inch** in the drop menu next to it.

 Computer images are made up of dots called *pixels. Resolution* is the measurement of how many pixels make up an area of an image. With this setting, each square inch of your image will be made up of a 72 × 72 grid of pixels.

5. From the **Mode** drop menu select **RGB Color,** because you are working on a color image.

6. In the **Contents** area click the **White** option to start with a white background.

7. Click **OK** and the new image window appears!

A DEEPER UNDERSTANDING: SCREEN RESOLUTION

The image on your screen is not actually 3 × 4 inches. Photoshop shows your image based on its pixel size rather than in inches. Your computer's display has its own resolution. For example, your entire display may be 800 pixels wide and 600 pixels high. Of that, your image takes up 216 pixels (3 inches × 72 pixels/inch) by 288 (4 × 72) pixels. How big this is depends on the size and resolution of your display. Seventy-two pixels per inch is a standard estimate for computer displays, but individual displays vary widely. Inch measurements are accurate only for printed images.

RESULT

PROCEDURE 2: GET THE ELLIPSE DRAWING TOOL

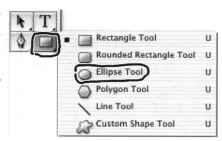

1. On the toolbox, point to the Shapes button (the button below the one with the **T**). Hold down your mouse button and a menu appears.

 If you do not see the toolbox, go to the **Window** menu and choose **Tools.**

2. Click **Ellipse** tool. The ellipse tool symbol now appears on the button you clicked, and the ellipse tool options now appear on the option bar.

 If you need to use the ellipse tool and the ellipse tool symbol appears on the button, you don't have to use the menu—just quickly click the button.

3. On the option bar click the **Create filled region** button to tell Photoshop you will be drawing a filled-in ellipse rather than creating an ellipse shape for another purpose.

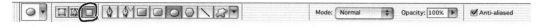

A DEEPER UNDERSTANDING: USING THE TOOLBOX

Photoshop has too many tools to show buttons for all of them. Most buttons are used for several tools. A button that has an arrowhead in the lower right has a menu. A quick click of the button gets you the tool currently pictured on the button, whereas keeping the button pre-set brings up the menu of tools associated with that button.

Each button has a one-key keyboard shortcut, which you can see by *hovering* on the button; that is, keep your pointer still over it for a second without pressing the mouse button. A button description tag appears, showing the name of the button's current tool and the shortcut in parenthesis. For example, hovering on the ellipse tool button brings up the tag *Ellipse tool (U)*. Press **u** and the ellipse tool is selected. If the ellipse tool symbol is not currently on the button, hold down the **shift** key while pressing **u** repeatedly. This cycles through the different shape tools so you can select any of them—not just the currently displayed one—through the keyboard. This shift trick works for the more common tools on the multitool buttons.

RESULT

PROCEDURE 3: PICK THE BEAR'S FUR COLOR

1. Find the color palette. It may share a small screen window with the swatches palette and the styles palette, in which case click the **Color** tab to bring that palette forth.

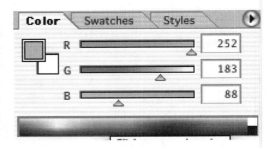

 If you don't see the color palette, from the **Window** menu, choose **Color.**

2. On the rainbow-colored band at the bottom of the color palette, click on the color that you want. (I suggest a tan, which you will find between the red and yellow at the left end of the band.) The color you click will appear in the foreground color area of your toolbox.

 Notice that the colors are lighter toward the top of the band.

3. Fine-tune the color using the strips marked **R, G,** and **B.** Each of these strips shows a range of color varying from the current color, which has an arrowhead pointing at it. Click on any color on those three strips to select that color.

 If a triangle with an exclamation mark in it appears, that is a warning that your printer can't print the exact color you have selected. Click this warning symbol, and Photoshop will select the nearest printable color.

A DEEPER UNDERSTANDING: SCREEN COLORS

Computer screens are made up of tightly woven dots of red, green, and blue. Any color you see on the display is made up by mixing a certain brightness of each of those three colors. For example, if a group of dots displays a moderate amount of red and blue but no green, you wil see a rich purple color. When you fine-tune your color, you are really adjusting how much red, green, and blue are mixed together to make the color, which is why they are marked **R, G,** and **B.** The brightness of each color is measured on a scale from 0 (totally dark) to 255 (fully bright). You can see the value for each component of the current color to the right of the component's adjustment band.

RESULT

PROCEDURE 4: DRAW THE HEAD AND EARS

1. Point to a spot about a quarter of the way down from the top of the image area just inside the left edge of the image area.
2. While holding down the **shift** key, *drag* (move the mouse while holding down the mouse button) toward the lower right. As you drag, a circle outline appears.

 Holding down the shift key tells Photoshop that you want a shape that is just as high as it is wide. A circle is just an ellipse with matching height and width.

3. When the circle is as big as you can make it without running off the side or bottom of the image area, release the mouse button. The circle will now be filled in with the color you selected.

 If you make a mistake, open the **Edit** menu and select the first command, which will be an **Undo** command. This command corrects almost any type of mistake you can make on your image.

4. To make the bear's left ear point to the edge of a circle at about the position where 10 o'clock would be if this were a clock face.
5. Hold down the mouse button, press down the Macintosh **option** or Windows **alt** key and drag the pointer to the 11 o'clock position on the head.

 Holding down the specified key tells Photoshop that you are starting your drag where you want the center of your shape to be. Otherwise, it thinks you are dragging from one corner to another corner of the smallest box the shape will fit in.

6. Repeat this step on the other side of the head to draw the other ear.

 Remember, you must be holding down the mouse button before pressing down the key. Doing these things in the opposite order has a totally different effect.

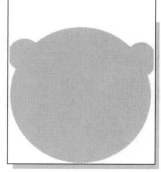

RESULT

PROCEDURE 5: GET THE PAINTBRUSH TOOL

1. Click the **Paintbrush** tool button (the keyboard shortcut is **b.**)

 If the paintbrush symbol is not visible on the button, select **Paintbrush** tool from the button's menu as seen in Procedure 2.

2. On the option bar click the **Brush** drop-down button. A scrollable set of pictures of different brush tips appears, showing brushes of different sizes, shapes, and solidity.

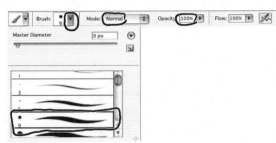

 If your list doesn't look like this image, click the arrowhead button in the upper right of the list and choose **Stroke Thumbnail** from the menu that appears.

3. Double-click the first size **9** brush tip. The list disappears.

 The number under each brush's picture is that brush's width measured in pixels.

4. From the **Mode** drop list select **Normal.**

 The *normal* setting is what you use when you want to paint the selected color on every pixel the brush passes over. The other settings are used to tint or alter the existing colors in various ways or to only affect some of the pixels.

5. If the **Opacity** field is not set to **100%,** point to the arrow at the end of the field and drag the slider that appears all the way to the right.

 Opacity is the opposite of transparency. The lower you set the opacity, the more the existing color will show through the color you are painting. You want totally solid (opaque) color.

R
E
S
U
L
T

PROCEDURE 6: DRAW THE FACE

1. Choose black as your color as shown in Procedure 3.

 There is an easy-to-click black square at the end of the rainbow-colored bar.

2. Point to where the bear's mouth should start and drag the mouse in the shape of a smile.

3. Point to where the left eye should be and drag the mouse in tight little circles to make an eye.

4. Repeat step 3 for the right eye and then make an even larger circle to make a nose.

 Don't worry; this isn't supposed to be a masterpiece. This is just a quick little fun drawing to expose you to much of the Photoshop interface.

. .

A DEEPER UNDERSTANDING: DRAWING DEVICES

If you have just used your mouse to draw an uneven, ragged smile on the bear, don't be ashamed. A mouse is great for clicking buttons and pulling down menus, but trying to draw with it is about as tricky as trying to type with a ouija board.

Use a *pressure-sensitive tablet* instead. This is a flat electronic board that you draw on with a penlike stylus. Move the stylus over the board without quite touching it and the pointer echoes that movement on the screen. Tapping the stylus against the board is the same as clicking the mouse button, and dragging the stylus across the board is the same as dragging the mouse. You will create lines and curves as smoothly as those you draw by hand, which may not be perfect, but are bound to be better than what you would do with a mouse.

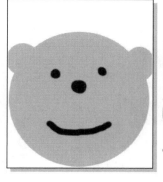

The "pressure-sensitive" aspect is that the stylus detects how hard you are pressing it against the tablet. Photoshop uses this sensitivity detection to treat your stylus like a felt-tip pen. Drag it lightly across the page and you will get a thin line. Press it harder, and a thicker line appears. A tablet increases the quality of your computer-drawn images immensely, and you can get a basic one for under $100.

RESULT

PROCEDURE 7: SAVE THE FILE

1. From the **File** menu choose the **Save** c o m m a n d (Macintosh short-cut: ⌘+s, Windows: **Ctrl+s**). A **Save As** dialog box opens.

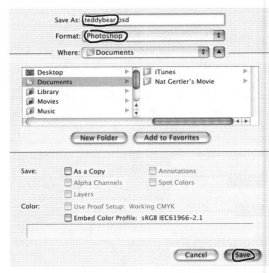

 If you opened an existing art file, or if you already saved this file once while editing it, this command will instantly overwrite the existing file, skipping steps 2 through 5. If you don't want to over-write the existing file, use the **File** menu's **Save As** command instead.

2. Type a name for your file (such as **teddybear**).

 After typing the name, you may see it automatically followed by *.psd*. This is a file name ending, which is also known as an *extension*, indi-cating a Photoshop file.

3. Select a directory to store the file in. You may need to click the down arrow button at the right end of the **Where** or **Save In** field to see the directory browser.

4. Make certain that **Photoshop** is selected from the **Format** drop menu.

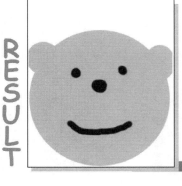

Photoshop supports many file formats, any of which would be fine for saving this simple picture in. However, it is good practice to save every-thing you do in Photoshop format because it stores more complex information about the image, which can make editing it later easier.

5. Click **Save.**

6. Now that you are done with your image file, go to the **File** menu and choose the **Close** command to close the image window.

PROJECT 2
COLOR IN A CARTOON

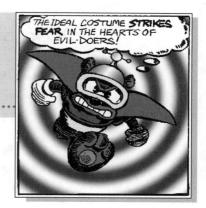

CONCEPTS COVERED

- ❏ Scanning
- ❏ Loading
- ❏ Setting color mode
- ❏ Zooming in and out
- ❏ Selecting
- ❏ Filling
- ❏ Gradients

REQUIREMENTS

- ❏ A cartoon line drawing, which can be scanned from this book or downloaded from the Web

RESULT

- ❏ A colored comics panel

PROCEDURES

1. Get the line drawing
2. Get a closer look
3. Fill in the easy areas
4. Plug up holes
5. Selecting multiple areas
6. Gradient fills
7. Selecting complex areas
8. Prestored gradients
9. Finish up

PROCEDURE 1: GET THE LINE DRAWING

1. *If you are connected to the Internet,* pull up:

 www.delmarlearning.com/companions/projectseries/

 on your Web browser. There you will find the image and instructions for downloading it to your hard disk. From the Photoshop **File** menu choose **Open** (Macintosh shortcut: ⌘+o, Windows shortcut: **Ctrl+o**), find and select your file then click **Open.** Skip to step 3, **or**

2. *If you are not connected to the Internet:* You have to scan the image off this page. From the **File** menu, choose **Import** then choose your scanner from the submenu. Set your scanning options to **300 dpi** and **Line art** or **Black and White,** then start the scan. (I can't tell you how to use your scanner's software, because every scanner is different.) The image will open in Photoshop.

TOY-BOX TALES BY GERTLER AND HALLER

 If you are using a slow computer or one with particularly low memory, just scan the third panel of the strip. That's the one I'm using as an example.

3. On the **Image** menu, point to **Mode** and select **RGB color** from the submenu to give yourself access to the full range of colors, not just the black and white of the image.

R E S U L T

 If you couldn't get your scanner to scan in Line Art or Black and White, from the **Image** menu choose **Adjust, Threshold,** enter a threshold value of 128, then click **OK.** This makes the black and white on the image pure, rather than including tough-to-work-with grays.

PROCEDURE 2: GET A CLOSER LOOK

1. Drag the lower-right corner of the image window down to the bottom of the screen.

 This maximizes the space you have to work on the image.

2. Click the **Zoom** tool button (shortcut: **z**) on the toolbox.

3. Drag from a spot just above and to the left of the bear's visor in the third panel to just below and to the right of it. When you release the mouse button, the visor enlarges. You haven't changed your image; you are just getting a closer look at part of it. The lines look jagged now because you have enlarged the image enough to see the individual square pixels that it make up.

4. On the navigator palette, there is a small image of your entire picture with a red frame indicating the portion displayed in your image window. Drag that frame to look at another part of the picture. Use the slider at the bottom of the palette to adjust the picture's magnification.

 If you don't see the navigator palette, go to the **Window** menu and choose **Show Navigator.**

. .

A DEEPER UNDERSTANDING: ZOOMING

Photoshop has different ways of adjusting the magnification of your image. With the zoom tool, you can select an area to enlarge as described previously. Click with the zoom tool to *zoom in on* (enlarge your view of) what you click. To *zoom out* (see more of the image), hold down the Macintosh **option** key or the Windows **Ctrl** key while clicking.

No matter what tool you are using, you can use commands on the **View** menu to adjust your zoom level. The **Fit on screen** command zooms out so that your whole image fits in the visible area. **Actual pixels** sets the zoom so that one pixel of your image takes up one pixel of the screen. **Print size** sets the display on your screen to about the same size the item will be when printed.

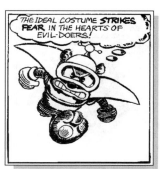

RESULT

PROCEDURE 3: FILL IN THE EASY AREAS

1. From the toolbox choose the **Paint Bucket** tool (shortcut: **g**).

2. Reset the tool's settings by pointing to the paint bucket icon menu at the left of the option bar. If you're using Windows, hold down the *right* mouse button. If you're using a Macintosh, hold down the **Control** key while pressing down the mouse button. Choose **Reset Tool** from the menu that appears; clear the **Anti-aliased** check box.

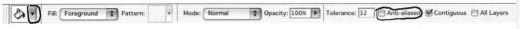

 These are the settings needed to replace solid, connected areas of one color with solid, connected areas of a different color. If you leave the anti-aliased option checked, Photoshop will mix the edges of the color you are adding with the color next to it. That creates a smooth look for low-resolution images such as Web graphics, but it is not needed for high-resolution items like this one. It also can make corrections difficult.

3. Choose the color that you want the bear's goggles to be, using the methods shown in Project 1, Procedure 3.

4. Click in the white area of the goggles. The white is replaced with the color you chose.

The Paint Bucket tool icon has a flow of paint pouring from the bucket. The bottom tip of that flow is the pointer of this icon. Make sure that tip is over a white area before clicking. (The more you zoom in, the easier it is to click the right area.)

5. Repeat steps 3 and 4 for the following parts of the image: the bear's furrowed brow, right ear, the cheeks, and the white areas of the arms—all of which should be the same fur color—the shirt, the pants, the glove, both sides of the cape, and the inside pad of the paw. You may need to zoom in very close to find the white parts of the cross-hatched areas. (Skip this step for any area that you want to leave white.)

The areas listed are the ones that are completely and solidly outlined and which you are painting a solid color. That makes them easy to fill.

PROCEDURE 4: PLUG UP HOLES

1. Choose the **Pencil** tool (shortcut: **b**) from the toolbox.

 The pencil tool is very much like the paintbrush tool that you used in Project 1, except it only makes marks of a solid color, whereas the paintbrush softens its color at the edges.

2. On the option bar pull down the **Brush** drop menu and double-click on the size **1** brush. Make sure the **Mode** option is set to **Normal** and the **Opacity** is set to **100%.**

 The size 1 brush draws a single pixel at a time, which is handy for very precise touch-ups.

3. While holding down the Macintosh **option** key or the Windows **ctrl** key, click on one of the fur-colored areas of the bear. This picks up the fur color, making it your current color again.

 This trick works with most paint tools, including the paintbrush and paint bucket. You can also use the **Eyedropper** tool (shortcut: **i**) to pick a color from the image at any time.

4. Zoom in on the bear's middle toe, using the zooming tools shown in Procedure 2. Notice that there is a clear white path out of the center of this toe. If you tried to fill the toe with the paint bucket, the color would pour out through this path and flood the rest of the image.

5. Using the pencil, fill in the end of the gap.

 When you select a size 1 pencil, the pointer becomes a crosshair. Click and the pixel at the center dot of the crosshair fills in.

6. Use the paint bucket to fill the toe and the rest of the paw.

7. Repeat this procedure with the bear's left ear.

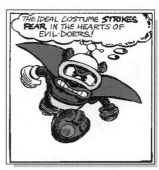

RESULT

PROCEDURE 5: SELECTING MULTIPLE AREAS

1. From the toolbox choose the **Magic Wand** tool (the keyboard shortcut is **w**).
2. On the option bar click the **New Selection** button, set **Tolerance** to **5,** and make sure the **Anti-aliased** option is not checked but the **Contiguous** option is.

You are about to click on a color to select the surrounding area that matches this color. The Tolerance setting defines how close a color match is needed for pixels to be selected. Set it to a low number like 5 and it will need a close match. Set it to a high number like 50 and it will accept a range of similar colors, which is handy when you are trying to select something in a scanned image where colors might vary slightly from pixel to pixel.

3. Click on the main white area of the helmet. The white area becomes selected and a *marquee* (a moving dotted line) flows around the edge of the white area, circling what you have selected.

4. On the option bar click the **Add to selection** button.

You are about to select more areas and you want the previous areas to stay selected as you do. Otherwise, when you select a new area, the previous area would be deselected.

5. Click the white areas of the stem on top of the helmet, the ball on top of the stem, and the two balls out to the sides. Marquees should now circle all of the white areas you clicked.

A DEEPER UNDERSTANDING: SELECTING

Selecting means showing the computer the areas of the image that you want to deal with. When an area is selected, most tools will work only in that area. For example, with the helmet selected, you could take the paintbrush and try to write your name on the bear's chest, but it would not have any effect. Try to write your name on the helmet, however, and not only would it work, but the superbear would have to arrest you for vandalism!

RESULT

PROCEDURE 6: GRADIENT FILLS

1. Use the color palette to select white as your foreground color.
2. Click on the background color area on the toolbox (the lower of the two over-lapping squares). A dialog box appears.
3. Click the **H** option button, then click midway down the left edge of the large **Select background color** box, then click **OK**.

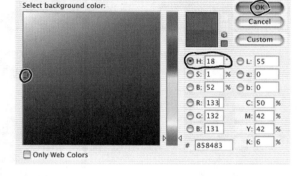

 With the **H** option chosen, the left edge has every shade of gray, so grays are easy to pick here. See the last page of the color section of this book for more on using the color picker.

4. Choose the **Gradient** tool (shortcut: **g**) from your toolbox.
5. Use the technique from Procedure 3 to reset this tool to its default settings.

 The default *gradient* (fade pattern) fades from foreground color to background color.

6. Click the **Reflected gradient** option button and make sure that **Mode** is set to **Normal** and **Opacity** is set to **100%**.
7. Point to the middle of the helmet then drag to the helmet's lower-right corner. When you release the mouse button, the helmet becomes shiny metal, reflecting white light near its center.

. .

A DEEPER UNDERSTANDING: BACKGROUND COLOR

Some functions require you to specify two colors. If the foreground color is Batman then the background color is Robin—which is not as useful and not seen as much but still handy to have around. You can set the background color on the color palette by clicking the over-lapped **Set background color** box before clicking on your color. Remember to click back on the **Set foreground color** box before the next time you set the foreground color. Switch the two colors by clicking the two-headed arrow by the colors on the toolbox.

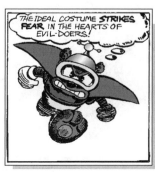

RESULT

PROCEDURE 7: SELECTING COMPLEX AREAS

1. Pull down the **Select** menu and choose **Deselect** (shortcut: Macintosh ⌘+d, Windows **Ctrl+d**) to start with nothing selected.

2. Use the magic wand as shown in Procedure 5 to select the image background. Clicking away from the bear selects most of the background but doesn't get the area between the bear's head and the balloon. Click again in the area to select it. Alas, this also selects the interior of the word balloon, which you don't want to color.

3. Choose the **Polygonal Lasso** tool from the toolbox (shortcut: l).

4. On the option bar click the **Subtract from selection** button. Make sure **Feather** is set to **0 px** and the **Anti-aliased** checkbox is clear.

5. Click where the balloon meets the top panel border in the upper-left corner. A box appears showing that this is where you are starting a path.

6. Go around the edge of the word balloon, clicking frequently on the black word balloon outline. Every time you click you are putting down a fencepost. You want the fence to enclose *only* the word balloon so stay on the black lines.

7. Double-click when you get to where the word balloon hits the top of the panel on the right side. This is the last fencepost so Photoshop builds the fence across the first post you put down. Everything within the fence is deselected.

8. Use the magic wand with the **Add to selection** option to select small areas that have not been selected: the two spots between the balloon and the right panel border and the area between the helmet's hood ornament and the word balloon.

RESULT

PROCEDURE 8: PRESTORED GRADIENTS

1. Select the **Gradient** tool from the toolbox.

2. On the option bar click the **Radial Gradient** button then click the drop list of gradients.

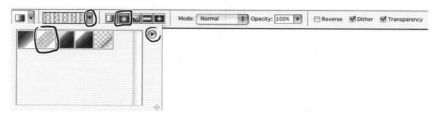

3. Click the **Options** arrow on the right side of the list and a menu appears.

4. Click **Special Effects** on this menu.

5. Photoshop asks you if you want the gradients in this file to replace the ones on the list. Click **OK.**

> When this is done, you can reset the gradients to the standard set by coming back to this menu and choosing **Reset Gradients.**

6. The second gradient on the list is made up of many diagonal lines. Double-click this.

7. Pick a bold foreground color and a different bold background color.

> Many prestored gradients use their own colors rather than the colors you select. This is not one of them.

8. Point to the bear's nose and drag to one of the corners of the panel. A pattern of concentric circles appears in the foreground color but with a slight glow of the background color. The circles are centered on the bear's nose.

> On the gradient display on the option bar, you saw checkerboard patterns between the colored bands. Those patterns indicate transparent areas; put that gradient over part of your image, and your image shows through those bands. Because you put the gradient over the white background, the end result alternates colored circles with circles of the white background.

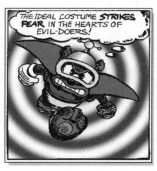

9. Deselect the selection by using the **Select** menu to choose the **Deselect** command.

PROCEDURE 9: FINISH UP

1. Set the foreground color to pure white.

2. From the **Select** menu choose **Color Range.** A Color Range dialog box appears.

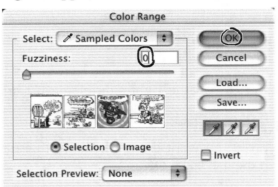

3. Set **Fuzziness** to 0 then click **OK.**

 You are using this command to select only the pure white areas of the image. Setting a higher fuzziness value would also select bright areas of different colors.

4. Zoom in on the crosshatched areas of the image and use the pencil tool (set to size **9**) to quickly fill in any stray white pixels with the appropriate color. Because only white areas are selected, you can't accidentally wipe out the black lines while doing this.

 It may look like you are leaving untouched white bits wherever you put the pencil. Don't worry; what you are actually seeing is the white of the marquee around the selection. Zoom in close so that the marquee is small compared with the area you are working on, and this shouldn't bother you much.

5. If you feel like using these techniques in the other three panels of the strip, go for it! (And tip your hat to Rusty Haller, the fine cartoonist who drew this. It first appeared in issue 4 of the comic book *The Factor.*)

6. Save your file as shown in Project 1, Procedure 7.

RESULT

Project 3
Baseball Card

POCO GERTLER
Wicked-cool stepmother

CONCEPTS COVERED

❏ Cropping
❏ Shapes
❏ Layers
❏ Layer styles
❏ Creating text
❏ Exporting

REQUIREMENTS

❏ A personal photo

RESULT

❏ A baseball-card style image at screen resolution, which could be used as a Web page decoration

PROCEDURES

1. Get the image to the right dimensions
2. Place a stripe for the text
3. Frame the picture
4. Fancify the frame
5. Add your name and position
6. Create a team logo
7. Export it for Web use

PROCEDURE 1: GET THE IMAGE TO THE RIGHT DIMENSIONS

1. Open a digital photograph of yourself. You can scan one in, as described in Project 2, Procedure 1, or you can use an already-digitized one.

 If you can't get a picture of yourself, use someone else's. There are plenty of pictures of people on the Internet that you can borrow.

2. Choose the **Crop** tool (keyboard shortcut: **c**) from the toolbox.

 Crop is the artist or design term for cutting the edges off things.

3. On the option bar, set **Width** to **3 in**, **Height** to **4 in** and the resolution to **72 pixels/inch.**

 The crop tool can resize the trimmed image. At 72 pixels per inch, a width of 3 inches (abbreviated *in*) is 216 pixels (which could be typed with the abbreviation *px*) and 4 inches is 288 pixels.

4. On your photo, drag from the upper left of where you want your image to start down to the lower right. The rectangular marquee that appears may not follow your pointer exactly; you have asked for a fixed height and width so it only selects areas with the right height-to-width ratio.

5. When you release the mouse button, everything outside of the marquee darkens. Double-click inside the marquee and the rest of the photo is cut away, leaving only the area you selected.

 Before double-clicking, you can move the cropping area by dragging from inside it, or adjust the area's size by dragging the corner, or even tilt the area by dragging just outside the edge of the area.

6. Double-click the **Zoom** tool button to see the cropped image at actual pixel size. (You may need to resize the window to see it all.) Photoshop resized your image to 2 inches × 3 inches at 72 pixels per inch. If your photo was scanned at a low resolution, or if you cropped a small area of the photo, it may now look fuzzy.

RESULT

PROCEDURE 2: PLACE A STRIPE FOR THE TEXT

1. In the color palette, click on a light yellow area. This will be the color of your text stripe.
2. Choose the **Rectangle** tool (shortcut: **u**) from the toolbox.
3. Reset the tool settings by using the same technique shown in Project 2, Procedure 3.
4. You want to place a rectangle that runs the full width of the image, including the frame, and about one-sixth of the height of the card. Point to the left edge of the image, about one third of the way up from the bottom, and drag to the right edge of the image, about one sixth of the way from the bottom. Some of the photograph should be visible below the rectangle.

A DEEPER UNDERSTANDING: LAYERS

When you add this rectangle, Photoshop doesn't erase the part of your photo that it covers. Because you used the rectangle tool's **Create new shape layer** option, the rectangle is treated as a separate item. The program considers the rectangle to be on a separate *layer* as though the rectangle is printed on a clear sheet, which you look through onto the picture below.

This is how animators worked precomputers. To show Mighty Mouse flying around a building, they painted a sky *background* with two *cels* (paintings on clear sheets) laying on it: one with Mighty Mouse and one with the building. By restacking those cels, they put Mighty Mouse in front of the building or behind it. When the animators slid his cel to the side he was just next to the building. They needed several cels of Mighty Mouse because he wiggles and waves his arms and turns around, but they only needed one building cel and one background cel, which were reused on every frame of film.

Photoshop layers are like that. You can rearrange them, restack them, or slide one to the side. You can do all kinds of things without destroying your original image, which is your background. You can even take a layer you created for one image and reuse it in another.

PROCEDURE 3: FRAME THE PICTURE

1. This card will have a border just like older baseball cards have. Drag the lower right corner of the image window down and to the right so that the window is larger than the image. Photoshop keeps your image in the center of the window and fills the area around your image with empty nothingness.

2. From the **Layer** menu choose **New, Layer.**

 You are going to make the frame using the rectangle tool. Because you had just set up a new layer by using that tool in the last procedure, Photoshop assumes that you want to continue working on that layer unless you tell it differently.

3. In the New Layer dialog box, type **Frame** into the **Name** field then click **OK.**

Notice that the word "Frame" is now on the bar at the top of the image window. To see it you may need to widen the image window by dragging the right edge. Photoshop lists the file name, zoom magnification, name of the current layer, and color mode of the image on this bar.

4. From the color picker, pick a color for the frame.

5. Using the rectangle tool, drag a rectangle that covers the entire image.

Rather than aiming for the exact corners of the image, you can start outside the edges of the image. That is why you enlarged the window.

6. Click the **Subtract from shape area** option (shortcut: −) on the option bar.

7. Starting a little inside the upper-left corner, drag a rectangle to a little inside the lower-right corner creating a rectangle slightly smaller than the image. This rectangle is subtracted from the rectangle that was there, leaving just the area between the two rectangles.

PROCEDURE 4: FANCIFY THE FRAME

1. From the **Layer** menu, choose **Layer Style, Bevel and Emboss.**

2. On the dialog box that appears, click the **Technique** drop menu and choose **Chisel Hard** to give the frame a hard-beveled edge.

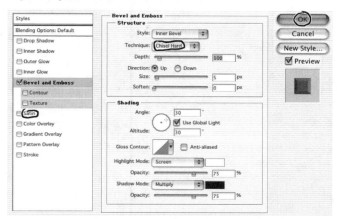

 If the **Preview** option is checked, the image shows the result of this setting while you work in the dialog box. (You may have to drag the dialog box out of the way to uncover your picture.) Under the Preview checkbox is a display of the current settings effects applied to a square.

3. In the **Styles** area, click the word **Satin.** This turns on the Satin style, giving your frame an interesting sheen and displays the Satin options.

 To turn on a different style while still viewing the options from your current style, click the check box next to the style name. Experiment with this; there are some nifty effects.

4. Click **OK** to close the dialog box and resume working with your image.

A DEEPER UNDERSTANDING: TYPES OF LAYERS

You can't take the paintbrush and paint on the picture now. When you drew those rectangles on it, Photoshop decided that the current layer is a *shape layer,* which can't handle tools that paint the individual pixels. A shape layer can only have a single color, a *cutting path* (the outline of the shape you make using the various shape tools), and the layer styles you add. These layers are handy—for example, you can easily go back and adjust the size of the rectangles later just by dragging the edge of the rectangle with the right tool. If you created a new layer and the first tool you use is a paintbrush, then Photoshop knows you want a *raster layer.* Although you can draw a rectangle on a raster layer, you can't resize it later—Photoshop forgets that it is a rectangle and sees it as a bunch of pixels that happen to be of the same color.

Other layers are *type layers* which display text; *fill layers* and *adjustment layers* which change the colors and appearance of the layers below them, much like viewing your image through a filter.

RESULT

PROCEDURE 5: ADD YOUR NAME AND POSITION

1. Choose the **Horizontal Type** tool (keyboard shortcut: **t**) from the toolbox.
2. Click the T symbol at the left end of the option bar and select **Reset** tool from the menu that appears.

 Resetting your tool takes you back to a standard set of tool options. Otherwise, the options you last used appear—which is fine when you know what you are doing (and you are the only one using Photoshop on this computer).

3. From the **Set the font family** drop list, choose **Arial Black.** Click the **Right align text** option.

4. Set the foreground color to black.
5. Drag the text tool from the upper-left corner of the yellow text stripe to the lower-right corner. A box for your text appears. (Photoshop also creates a new text layer for the text to appear on.)

 The pointer has a capital I shape with a small horizontal line near the bottom. The intersection of that horizontal line and the vertical line is the thing that you want to aim at the corners.

6. Type your name IN ALL CAPITAL LETTERS, then hit the Macintosh **return** key or the Windows **enter** key.
7. On the option bar, use the **Set the font size** drop menu to choose **10 pt.**

 Pt is short for *Points,* the measurement of text size. You want this second line of text to be smaller.

8. Type a position such as *pitcher.*
9. Choose the **Move** tool from your toolbox.
10. Use this tool to drag your text, keeping it toward the right side of your text stripe and nicely centered.

 This tool is not just moving the text—it moves the entire layer that the text is on.

POCO GERTLER
Wicked-cool stepmother

PROCEDURE 6: CREATE A TEAM LOGO

1. Get the **Horizontal Type** tool again and drag a text box across the top of the picture inside the frame. This creates another new layer. Each text box gets its own layer.

2. On the option bar, set the font to **Comics Sans MS,** the font style to **bold,** the size to **30 pt,** and click the **Center text** option.

3. Type a name for your team IN ALL CAPITAL LETTERS.

4. Around the edges of the text box are eight *sizing handles:* sizing handles are little boxes that you can drag to adjust the size of the text box. Drag the one on the center of the lower edge of the logo so that the box is only a little taller than the text it contains. Drag one of the handles on the center of the sides so that the box is just wide enough to hold the text.

5. Move your pointer an inch below the text box. The pointer should now be a curved line with two arrowheads. Drag and the text box starts tilting. Tilt it up at about a 15-degree angle.

6. Click the **Create warped text** button on the option bar.

7. In the dialog box that appears, click the **Style** drop list and choose **Fish** then click **OK.**

 When you apply the Fish style to long, thin text, it will have the shape of a baseball bat.

8. Pull down the **Window** menu and choose **Styles** to see the styles palette.

 Does your color palette have a styles tab on it? If so, click the tab to get the styles palette.

9. Click on the various style buttons pictured there and see what effect they have on your logo. When you find one you like, stop!

 These style buttons apply interesting combinations of layer styles to the current layer. Click the option arrow in the upper left of the palette to see commands to load more styles.

R E S U L T

Procedure 7: Export it for Web use

1. Save a copy of your image in Photoshop format as described in Project 1, Procedure 7.

 If you want to go back later and do some more work on this baseball card, save a copy in Photoshop's native format. The file you are going to save for the Web will lose all of the information about the separate layers turning everything into one raster layer. You won't be able to go back and edit text or change the placement of the text stripe.

2. From the **File** menu, choose the **Save for Web** command.
3. On the Save for Web dialog box that appears, go to the **Settings** drop menu and choose **JPEG Medium.**

 This step selects both the Web graphics file format you are using (JPEG) and the amount of compression (Medium). The more you compress your image, the quicker it is to download but the worse it looks. Experiment with the different settings; when you pick one, the **Optimized** tab shows what your image looks like compressed that way. Below the image is information on how big the file will be and how long it will take to download with those settings.

4. Click **Save** and a file browser appears.
5. Choose a name and location for your file, then click **Save.**

A DEEPER UNDERSTANDING: WEB FILE FORMATS

Web browsers support three graphics formats. *JPEG* is the best for photos because it supports the full range of colors. It compresses photos by creating color irregularities. It is only good for rectangular images, because it doesn't support transparent areas. *GIF* can only show 256 different colors per image; for more colors, choose a *dithering* option (alternating pixels of two colors to fake a third color). It is good for logos, buttons, and simple drawings, and does support transparency. *PNG* is a lot like GIF but older Web browsers don't support it.

PROJECT 4

MAKE YOURSELF A MARTIAN

CONCEPTS COVERED

❏ Clone brush
❏ Cropping
❏ Liquifying
❏ Replace color
❏ Lens flare filter
❏ Smudge

REQUIREMENTS

❏ A facial photo

RESULT

❏ A picture of an oddly familiar-looking Martian

PROCEDURES

1. Grow a third eye
2. Expand your brain
3. Shrink your nose
4. Raise your eyebrows
5. Turn yourself green
6. Make your three eyes glow
7. Give yourself horns

PROCEDURE 1: GROW A THIRD EYE

1. Open your photograph.

 Although you can do this process with any size photograph, I find that the results come out better if you use a small or low-resolution one (say, 300 pixels high) rather than a large or high-resolution one (2400 pixels high). Certainly, the glowing eyes turn out better.

2. Choose the **Clone Stamp** tool (shortcut: **s**) from the tool palette.

 Be careful; this tool shares the palette location with the pattern stamp tool, which has a very similar button image.

3. Reset the tool's settings using the technique from Project 2, Procedure 3.
4. While holding down the Windows **Alt** key or the Macintosh **Option** key, click on the center of one of your eyes.
5. No longer holding down a key, point to where you want to add an eye. The center of the forehead is good, as is the chin or even a cheek.
6. Drag the mouse in little circles. As you do, you will see two pointers on the screen: one in your eye where you clicked, and the other where you are adding the new eye. Watch the one on your original eye and try to trace around all the visible counters of the eye. As you do, portions of the eye are copied to the new location. Keep dragging across portions of the eye until the whole new eye is in place.

RESULT

PROCEDURE 2: EXPAND YOUR BRAIN

1. Choose the **Crop** tool (shortcut: **c**) from the tool palette.
2. Reset the tool's settings.

 This is particularly important in this step. When you used the crop tool in Project 3, you used it not only to trim the sides off the image but also to resize it to specific dimensions. If you leave those options set that way, this image will be resized when you crop it. At this point, you only want to trim, not to resize.

3. Drag a rectangle that encloses your entire head and hair.
4. Put a check in the **Perspective** option on the option bar.

 This option lets us choose a nonrectangular four-sided crop area and then stretches the cropped picture to fill a rectangular area. This is handy when trying to pick a sign off a picture of an angled wall, for example, because it makes a good attempt to flatten the sign out so you see what it looks like head-on. Here, however, we are using it to warp your image in interesting ways.

5. Drag the sizing handles of each of the upper corners of the crop area inward so that the sides of the cropping area just touch the side of your head or hair, and the top is about a nose-height above the top of your head. If your picture doesn't have that much extra space at the top, just make it as high as you can.

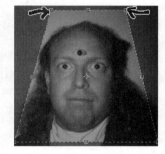

6. Double-click inside the cropped area. The image outside of the cropping area will be cut away, and the remaining image is stretched back into a rectangular shape, enlarging your cranium.

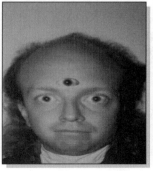

RESULT

PROCEDURE 3: SHRINK YOUR NOSE

1. From the **Filter** menu choose **Liquify.** A new dialog box opens up, displaying your image with a new set of tools.

2. Click the button for the **Pucker** tool (shortcut: **p**) on the left side of the dialog box. As you pass your pointer over the image, you will see that it has become a circle.

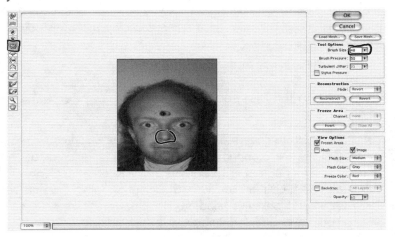

3. Use the **Brush size** option to make the circle about the same width as your nose at its widest point. (You may need to try a few sizes until you find one that fits.)

4. Put the center of the circle over the tip of your nose and press the mouse button down. While you hold it down, your nose will shrink, drawing in on its center. Once your nose looks inhuman, release the mouse button.

- -

A DEEPER UNDERSTANDING: LIQUIFY

You will get a better idea of how the Liquify command works if you go to the **View Options** area and select the **Mesh** option. This command views your image as a gridwork of smaller areas. When you use one of the tools to shrink something, expand something else, or generally to warp your image, it warps the segments of the grid.

Use the bottom two buttons on the left to get tools that let you mark certain areas of the image as "protected." For example, you could paint your nostrils then shrink the rest of your nose around them so your small nose has disproportionately large nostrils.

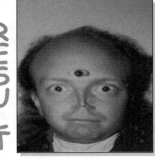

RESULT

PROCEDURE 4: RAISE YOUR EYEBROWS

1. Click the button for the **Warp** tool (shortcut: **w**) on the left side of the Liquify dialog box.
2. Center the brush circle just above the center of the left eyebrow and drag it up. Your eyebrow will rise to a point.
3. Repeat step 2 for your right eyebrow.
4. Click **OK** to close the dialog box and resume working with your image. Photoshop may take a few seconds or up to a minute before you can continue editing your picture.

 The image displayed in the dialog box may be much smaller than your actual image measured in pixels. While you are working on the image, Liquify only applies the changes to this reduced version of your image. Once you are done and click **OK,** the changes you made are repeated on the full version of your image. This takes time because warping the image requires a lot of calculations—the larger the image, the more time it takes.

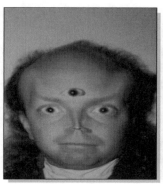

RESULT

PROCEDURE 5: TURN YOURSELF GREEN

1. Choose the **Eyedropper** tool (shortcut: **i**) from the tool palette.
2. On the option bar, click the **Sample Size** drop menu and choose **5 × 5 Average.**

 The eyedropper tool selects the color from where you click on the image. The color in photographs is not smooth and sometimes an individual pixel may have a color that is significantly different from the surrounding colors. This option checks the color of not just the pixel that you selected but 24 surrounding pixels as well, averaging them together to get a representative color.

3. Find a point on your skin where the color is roughly your average skin color and click it.

 If the color you select goes to your background color rather than to your foreground color, you have the background color square selected on your color palette. Click the foreground color square and repeat.

4. From the **Image** menu choose the **Adjustments, Replace Color** command.

5. Drag the pointer on the **Fuzziness** slider until your face is mostly white on the diagram below the slider but other major parts of your picture are black.

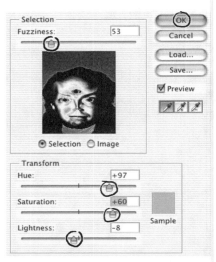

 You are about to change the colors that are close to your foreground color. The fuzziness setting says *how* close they have to be. In the diagram, white means that the color will change, whereas black means it won't.

6. Slide the **Hue** slider until you find a good, traditional Martian green. Fiddle with the **Saturation** and **Lightness** sliders until you get a nice, unhealthy glow. Then click **OK.**

 Make sure the **Preview** option is checked and then keep an eye on your image as you work on the dialog box. (You may need to drag aside the dialog box to see it.) That way, you can see what your image looks like with the color in place, enabling you to adjust the color accordingly.

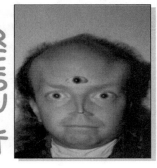

RESULT

PROCEDURE 6: MAKE YOUR THREE EYES GLOW

1. From the **Filter** menu choose **Render, Lens Flare.** This command is designed to simulate the sort of radiant light and stray circles that show up in photos of bright light sources or reflections, and it should do just fine for giving you glowing eyes.

2. In the **Flare Center** area click on the center of one of your eyes. The crosshairs move there.

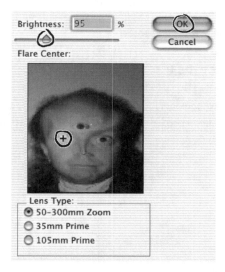

3. Adjust the brightness until the flare looks good. If you have fair green skin like mine, you will probably need to dim the brightness of the lens flare so that it doesn't wash out the rest of the image.

4. Click **OK.**

5. Repeat steps 1 through 4 for your other two eyes.

 When you go back for the second eye, you will see a **Lens Flare** command on the main **Filter** menu. The first command on that menu is always to repeat the last filter command. Don't use it here, however, because it repeats the command with the exact same settings—in other words, it will put a second lens flare right on top of the first. Instead, make sure to go into the **Render** submenu.

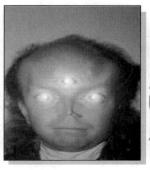
RESULT

PROCEDURE 7: GIVE YOURSELF HORNS

1. Choose the **Smudge** tool (shortcut: **r**) from the tool palette.
2. Reset the tool.
3. Choose a brush size so that the brush pointer is about the same size as the iris of your eye.

 This is just an estimate of what makes a nice little horn. Because you and I aren't dealing with the same picture in the same resolution, I can't tell you a specific size to make it.

4. Point the pointer to just below the top of your hair (or, if you are like me, your lack of hair) on the left side of your face.
5. Drag the pointer up, curving toward the right. This smears the color, as if your drawing was made of wet paint, and should leave you with a curved horn.

6. Mirror step 5 on the right side of your head.
7. Save the image.

 Don't be disappointed if you don't make an impressive-looking Martian. As you can see, when I do this to my own photo, I end up looking like a mug shot taken after drinking too much at a disco. When I did it to my stepmother's picture, however, she looked like she was going to take over the world. But now that you know the powers of liquefying and replacing colors, you can choose how best to redesign yourself as an Earth-imperiling alien.

RESULT

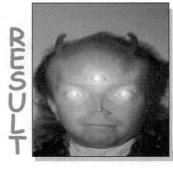

Project 5

Make Yourself a Martian Army

CONCEPTS COVERED

- ❏ Transforming
- ❏ Magnetic lasso
- ❏ Cutting
- ❏ Pasting
- ❏ Multiple pasting
- ❏ Difference clouds filter
- ❏ Invert
- ❏ Switching windows
- ❏ Using history
- ❏ Opacity

REQUIREMENTS

- ❏ The image that you made in Project 4

RESULT

- ❏ An image full of Martians

PROCEDURES

1. Select your head
2. Reduce your head
3. Make a Martian background
4. Make a column of yourself
5. Flip yourself
6. Roboticize yourself
7. Get your big head back
8. Loom over the background

PROCEDURE 1: SELECT YOUR HEAD

1. Open the Martian picture that you created in Project 4.
2. Choose the **Magnetic Lasso** tool (shortcut: 1) from the toolbox, and reset the tool.

 The usual rectangular or elliptical selection tools would be fine if your head were a perfect square or circle. This tool detects the edge of irregularly shaped objects and selects them.

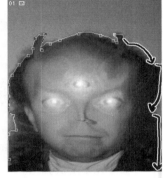

3. Click on a point at the top of your head. Move the pointer slowly along the shape of your head. As you move, the marquee adheres to the edge of your head. It may wiggle about a bit as you move as it tries to find the edge.

 If your background is about the same brightness as the top of your head, Photoshop may have trouble finding the edge. Try reducing the **Edge Contrast** value on the option bar.

4. When you have moved about a quarter of an inch, click to set the next point. The segment of marquee between the two points is locked in place and stops wriggling. Continue moving around the edge of yourself and clicking frequently.

If you move the pointer too far without clicking, Photoshop will automatically set down some locked-in points. This is handy but sometimes it will miss the edge and click in a wrong spot. You can undo recently added points by pressing **Delete.**

5. When you have gone all the way around the head and are almost back where you started, double-click. Photoshop will connect your last point to the first point. Your head is now selected.

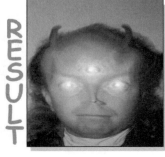

R
E
S
U
L
T

A DEEPER UNDERSTANDING: THE THREE LASSO TOOLS

The **Lasso** tool selects exactly the path you drag; if you drag accurately, you can select anything with it. The **Polygon Lasso** tool connects points you click with straight sides. The **Magnetic Lasso** tool tries to find the edge of the object you are moving along.

PROCEDURE 2: REDUCE YOUR HEAD

1. If you don't see the info palette, go to the **Window** menu and choose **Info.**

 On some systems, the info palette can be brought up via a tab on the navigator palette.

2. Click the arrow button in the upper right of the palette. Choose **Palette Options** from the menu that appears.

3. In the Info Options dialog box, choose **Pixels** from the **Ruler Units** drop menu, then click **OK.**

4. From the **Edit** menu, choose **Transform, Scale.**

5. A box with sizing handles appears around your selection. While holding down the **shift** key, drag the upper-right corner handle down and to the left. Your head shrinks as you do this.

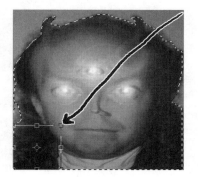

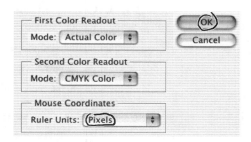 Holding down the **shift** key tells Photoshop that you want to keep the height-width ratio of the selection the same. Without the shift key, you could make your face short and wide or tall and thin.

6. Keep an eye on the lower-right corner of the Info tab. Drag until the **W** (width) value there is **72** (pixels).

7. Click the check mark at the right end of the option bar to indicate you are done transforming the selection.

8. From the **Edit** menu choose **Copy** (shortcut: Macintosh ⌘+c, Windows **Ctrl+c**). This copies the selection onto the *clipboard,* a storage area of memory that can be easily accessed by not only other Photoshop commands but also by commands from many programs.

RESULT

PROCEDURE 3: MAKE A MARTIAN BACKGROUND

1. *Without* closing the image you already have open, start a new picture as shown in Project 1, Procedure 1. Make this image **5 inches × 5 inches**, at **72 pixels/inch.**

2. Set red as the foreground color and white as the background color.

3. Create a basic red-to-white fade gradient as shown in Project 2, Procedure 6.

4. Click the **Radial Gradient** button on the option bar.

5. Point to a point a half-inch down and a half-inch in from the upper-right corner then drag an inch to the left. A glowing red orb appears. This is the Martian sun. (What? Martians have the same sun we do? Then maybe this is a Martian moon.)

6. From the **Filter** menu, choose **Render, Difference Clouds** to color the Martian sky.

7. Choose the first command on the Filter menu (shortcut: Macintosh ⌘+f, Windows **alt+f**). That command slot is always used to repeat the most recent filter command, in this case, **Difference Clouds.** Do this command 14 times.

 It is much easier to do this 14 times using the keyboard shortcut rather than the mouse.

A DEEPER UNDERSTANDING: DIFFERENCE CLOUDS

Difference clouds is a strange name but it is not meaningless. There is a **Clouds** filter that fills the selection with wispy foreground-colored clouds against a background-colored sky. *Difference* is an option for many tools, such as the paintbrush; if you paint with this option set, Photoshop compares each pixel's color to the foreground color, sees which is darker, and subtracts the red, green, and blue values of that color from the same values in the lighter color. Subtract red from white and you get aquamarine. Subtract white from white and you get black.

The Difference Clouds command generates random clouds then shows you the difference between the cloud color and the existing color at each point.

PROCEDURE 4: MAKE A COLUMN OF YOURSELF

1. From the **Edit** menu choose **Paste** (shortcut: Macintosh ⌘+**v**, Windows **Alt+v**) to copy the Martian head image from the clipboard and paste it over the Martian sky. This creates a new layer with just your head.

2. Choose the **Move** tool (shortcut: **v**) from the toolbox.

3. Drag your Martian head so that it is about half an inch from the left side of the image, and the top of your head is about halfway down from the top.

4. Choose the **Magic Wand** tool (shortcut: **w**) and click anywhere on the image **except** on your head. A marquee appears around the edge of the image and another appears around your head, indicating that everything between the two marquees—everything but your head—is selected.

 The magic wand is selecting all of the connected matching colors **on the current layer**. Because the only visible part of this layer is your head, the rest of the layer is transparent. Photoshop treats "transparent" as a color and selects all of the connected transparent areas.

5. From the **Select** menu, choose **Inverse**. This deselects everything that had been selected and selects everything that had been deselected, so now only your head is selected.

6. Choose the **Move** tool again, and while holding down the Macintosh **option** key or the Windows **alt** key, drag the head downward. You will find you are dragging a new copy of the head while the original one sits there. Drag it so that the top of the new head is just under the nose of the old head then release.

 Holding down the **option** or **alt** key indicates that you want a copy. Without it, you would have been just dragging the selection to a new place.

7. Repeat step 6 with the new head, making another copy of it lower down. Keep doing this until the bottom of one head goes off the bottom of the image.

RESULT

Procedure 5: Flip Yourself

1. From the **Edit** menu choose **Paste** to create another new layer with another copy of your Martian face. (It will appear just over the last copy of the face you made.)

 If you paste when there is a selection, the pasted object appears where that selection is. If you paste when there is no selection, the pasted object appears in the center of the image.

2. Use the **Move** tool to drag this head toward the right side and up, to balance where you put the first head on the left.

3. From the **Edit** menu choose **Transform, Flip Horizontal** to create a mirror image of your head.

4. From the **Image** menu choose the **Adjustments, Invert** command. This will replace all the colors in your head with their direct opposite; your green skin becomes purple, for example, and if you have black hair, it becomes white.

5. Follow steps 2 through 6 of Procedure 4 to drag down a copy of this head.

6. From the **Image** menu choose the **Adjustments, Invert** command again. This will reverse the colors back to their original colors.

7. Repeat steps 5 and 6 until you have a column of heads that touches the bottom of the image.

RESULT

PROCEDURE 6: ROBOTICIZE YOURSELF

1. From the **Select** menu choose **Deselect.**
2. Paste in a new copy of the head. Leave it in the center of the image.
3. Select the head, using the same technique you did in Procedures 4 and 5.
4. From the **Filter** menu choose **Stylize, Find Edges.** This creates a basically white image of your head, with colored outlines of various features wherever the color changes. Usually, this gives an odd mechanical look to people.
5. There is no need for the mouse here. With your left hand, hold down the Macintosh **option, ⌘,** and **shift** keys, or the Windows **alt, ctrl,** and **shift** keys. With your right hand, tap the **cursor down** key. A new copy of the robot head appears exactly 10 pixels lower than the original.

 Each key you are pressing modifies your command in a specific way. First is the ⌘ or **ctrl** key—holding down this key tells Photoshop that for the moment, you want to use the Move tool instead of whatever tool you currently have selected. This works in temporarily replacing the Magic Wand tool (and would replace most, but not all, other tools you may be using). As you have seen before, using the **option** or **alt** key with the Move tool means that you want to copy what you are moving, rather than just moving it. When you are using the Move tool, the cursor keys nudge the item in the specified direction. Usually the key nudges the item a pixel at a time but when you hold down the **shift** key, it moves it 10 pixels at a time.

6. Do step 5 repeatedly until you end up with a line of robot heads going all the way down to the bottom of the image. They will all be evenly spaced, exactly lined up, and close together—the way well-made robots should be.

RESULT

PROCEDURE 7: GET YOUR BIG HEAD BACK

1. At the bottom of the **Window, Documents** submenu is a list of Photoshop images you currently have open. Select your original Martian head.

 You can quickly flip through open images by pressing **ctrl+tab.**

2. If the history palette is not open, go to the **Window** menu and choose **History.**

 The history palette may share a window with the action palette. Click the **History** tab.

3. The history palette lists the most recent actions you have performed on this image. The bottom of the list is the most recent action, **Free Transform.** Click the entry above **Free Transform.** The image reverts to its state before you resized the selection—a big, selected head.

 The last action you performed on this image was **Copy,** but that changes the clipboard, not the image, so it is not listed here. The previous command, **Transform, Scale,** is represented on the list as **Free Transform,** a flexible command that can do any transformation.

4. From the **Edit** menu choose **Copy** to copy the full-sized head onto the clipboard.

5. You are done with this image, so from the **File** menu choose **Close.** When asked if you want to save the changes you have made, click **Don't Save;** you still have the disk file you started with.

A DEEPER UNDERSTANDING: UNDOING

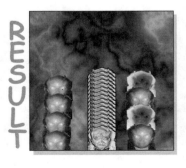

Click any black entry on the history list and you undo every image-changing step you have taken since that entry. All the undone steps on the list turn gray—click on one of the grayed-out steps before taking any other actions, and all the steps up to and including that step are redone. There are relevant commands on the **Edit** menu: **Step Forward** and **Step Backward** move down and up the history list, whereas **Undo** undoes the last action, even removing it from the history list and restoring the history list to its previous state. Choose **Undo** twice in a row, and you undo your undo, ending up back where you started (except those few seconds of your life are gone!).

PROCEDURE 8: LOOM OVER THE BACKGROUND

1. Paste the big head on the new image. If your original image was large, only a portion of your head may be visible.

2. On the **Layers** palette, click the drop list that now says **Normal** and choose **Lighten.** The big head takes on a ghostly, see-through appearance, merely lightening the colors behind it rather than hiding them.

 If this palette is not open, go to the **Window** menu and choose **Layers.**

3. Click the **Add a layer style** button on the Layers palette and choose **Outer Glow** from the menu that appears. Set the **Size** field to **100** and click **OK.** Your big head is now a glowing, ghostly head.

4. From the **Layer** menu choose **Arrange, Send to Back.** The head will now be behind all of the smaller heads, a great symbolic Martian overlord overlooking his troops.

 The giant head is still in front of the Martian sky because that is on the background rather than on a layer. The background will always be at the bottom of the stack.

5. Drag the giant head into a position that you think looks impressive.

6. Save the file (suggested title: **Martian army recruiting poster**).

RESULT

PROJECT 6

A SINGLE-IMAGE COLLAGE

CONCEPTS COVERED

- ❏ Canvas resize
- ❏ Background limitations
- ❏ Linking layers
- ❏ Aligning
- ❏ Distributing
- ❏ Adjustment layers
- ❏ Fill layers
- ❏ Masks
- ❏ Unlinking masks

REQUIREMENTS

- ❏ A color digital photo. It doesn't really matter of what, although it will come out looking better if it is a clear shot of a single person or item, rather than a landscape or a group shot.

RESULT

- ❏ A collage of variations on a single image.

PROCEDURES

1. Shrink your photo
2. Create the collage
3. De-background your background
4. Line up the diagonal
5. Flatten your sides
6. Create a semi-black-and-white shot
7. Pattern your photo
8. Hide behind an invisible corner
9. Dissolve a photo

PROCEDURE 1: SHRINK YOUR PHOTO

1. Open the photo.
2. From the **Image** menu choose **RGB Color**.
3. Return to the **Image** menu and choose **Image Size.**
4. On the Image size dialog box clear the **Constrain Proportions** check box.

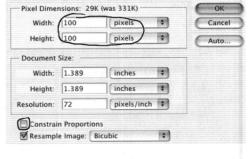

 This option keeps the height-to-width ratio the same from the original image to the resulting image. Since you want to squish the image down into a square, this won't do.

5. In the Pixel Dimension area, set both **Width** and **Height** to **100 pixels.**
6. Click **OK.** The image now reduces to a 100 × 100 pixel square.
7. Set your background color to something that will contrast well with your image. If you have a light image, pick a dark background color, or vice versa.
8. From the **Image** menu choose **Canvas Size.**
9. On the Canvas Size dialog box, set both **Width** and **Height** to **400 pixels.** Click the center block in the **Anchor** grid.

 You use the Anchor grid to choose in which directions the "canvas" stretches. Picking the center means you want your existing image to be in the center with new image area around it on all sides.

10. Click **OK.** The 100 × 100 image is now in the center of 400 × 400 pixel area of background color.

PROCEDURE 2: CREATE THE COLLAGE

1. Use the method shown in Project 5, Procedure 4 to select just the photo, not the expanded canvas area.

2. From the **Edit** menu choose the **Copy** command (Macintosh shortcut: ⌘+c, Windows: **Alt+c**). The photo is copied to the clipboard.

3. From the **Edit** menu choose the **Paste** command (Macintosh shortcut: ⌘+v, Windows: **Alt+v**). A new layer with the photo appears. Don't worry if you don't see a separate photo; it appears right on top of the original photo!

4. With the **Move** tool, drag the copy of the photo into the upper-left area of the canvas. (See? There was another copy hiding behind the one you dragged!) Don't put it flush up against the edge of the image.

5. Add copies of the image to the other three corners of the canvas by repeating steps 3 and 4. Don't worry about placing them precisely or spacing them evenly; you will even them up in the next few procedures.

RESULT

PROCEDURE 3: DE-BACKGROUND YOUR BACKGROUND

1. On the layers palette go to the very bottom of the layer list to find the background. Click on the *thumbnail* (the small version of the background's image) to select it.

 If you do not see the layers palette, go to the **Window** menu and choose **Layers.**

2. From the **Layer** menu choose the **New, Layer From Background.**

 This tells Photoshop to stop treating the background as a background, but to treat it as just another layer.

3. A dialog box appears. Click **OK** and your background will now be a layer. On the layers palette you will see its new name: *Layer 0.*

A DEEPER UNDERSTANDING: LAYERS VERSUS BACKGROUNDS

A background may seem like just another layer—You paint on it, use your various tools on it, and so on. However, Photoshop lets you do things with layers that you cannot do with the background. You can't move it; the edges of the background are the edges of the image and are fixed in place. You can't restack it; the background always stays underneath the entire pile of layers. The background can't have any transparent or translucent areas; if you try to create a new image with a transparent background, Photoshop instead creates an image with a transparent layer and no background. You can't feed it to your cat (you can't feed a layer to a cat either, but at the moment my cat is meowing hungrily, so this seems important).

After turning your background into a layer, you can do all these things (except feed poor Putt-Putt). And if you find the need to have a background again, just select a layer, go to the **Layer** menu and choose **New, Background From Layer.**

RESULT

PROCEDURE 4: LINE UP THE DIAGONAL

1. With Layer 0 still selected, find the layers palette entry that shows the photo located in the lower-right corner of the image. Click the empty box at the left of the layer thumbnail. A chain-link symbol appears in the formerly empty box.

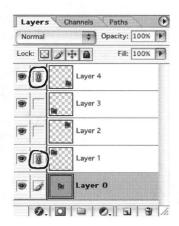

 This chain indicates that the image is *linked* to the currently selected layer (Layer 0), which means that you can take certain actions that will affect both the selected layer and this one.

2. Do the same thing again for the layer with the photo in the upper left. Now three layers are linked together.

3. From the **Layer** menu choose **Distribute Linked, Horizontal Centers.** Layer 0 moves somewhat.

 This command finds the linked layers with the leftmost and rightmost centers then moves the other linked layers sideways so that they are evenly spaced between those two layers.

4. From the **Layer** menu choose **Distribute Linked, Vertical Centers.** Layer 0 moves somewhat. The center photo on Layer 0 should now be precisely lined up in between the upper-left photo and the lower-right photo.

 This is the same sort of adjustment again, only up and down instead of side to side.

5. Because you have moved Layer 0, you now see a checkerboard pattern (indicating transparency) along the image's edges. Use the **Move** tool to move the linked layers so they cover this pattern.

 If this isn't easy, go to the **View** menu and ensure that both **Snap** and **Snap To, Document Bounds** have check marks. If not, choose those commands to make the layers you are moving automatically stick to the image's edges.

6. Click the two chain symbols on the layers palette to unlink those layers.

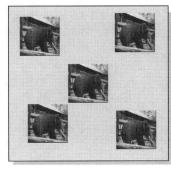

RESULT

PROCEDURE 5: FLATTEN YOUR SIDES

1. Select the layer with the upper-left photo, and link the layer with the upper-right photo to it, using the method from the previous procedure.

2. From the **Layer** menu choose **Align Linked, Top Edges.**

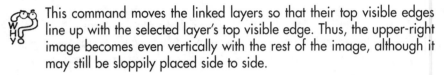 This command moves the linked layers so that their top visible edges line up with the selected layer's top visible edge. Thus, the upper-right image becomes even vertically with the rest of the image, although it may still be sloppily placed side to side.

3. Unlink the upper-right image.

4. Link the lower-left image and repeat the process, this time aligning **Left Edges.**

 If your current tool is the Move tool, there are buttons for all of the align and distribute commands on the option bar.

5. Select the layer with the lower-right photo, link the upper-right photo, align the **Right Edges,** then unlink.

6. Link the lower-left photo layer, align **Bottom Edges,** then unlink. Now, all five images should be evenly aligned and spaced.

If any of the photos suddenly move to the wrong place or disappear entirely during this process, you probably left something linked that was supposed to be unlinked. Undo the last step you did by going to the **Edit** menu and choose **Undo**, then unlink the errant layer and try again.

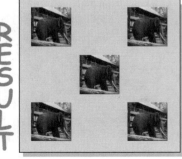

RESULT

PROCEDURE 6: CREATE A SEMI-BLACK-AND-WHITE SHOT

1. Select the layer with the photo in the center and on that layer select the photo.

 When you have a lot of layers, it is hard to use the thumbnails to identify the layer for any particular visible item. Instead, use the **Move** tool and check the **Auto Select Layer** option on the option bar. Then click any visible portion of the image, and the layer with the visible area becomes selected.

2. From the **Layer** menu choose **New Adjustment Layer, Threshold.**

 Threshold is an adjustment that turns an image into stark black and white.

3. On the New Layer dialog box that appears, set **Opacity** to **60%,** then click **OK.**

 With this setting each pixel will have 60% of what the image would look like in black and white and 40% of what the image would look like unadjusted. This way, you lighten the light areas and darken the dark areas, rather than making the image totally black and white.

4. Make sure the Threshold dialog box that appears doesn't block your view of the photo and that **Preview** is selected.

5. Adjust the slider until about a quarter of your photo is dark. The slider sets how light a pixel has to be before it is considered a light part of your image. The right setting for this depends on your image. Once your photo looks good, click **OK.**

A DEEPER UNDERSTANDING: ADJUSTMENT LAYERS

All types of adjustment layers have the same basic effect as commands on the **Image, Adjustments** submenu. However, those commands change the current layer only. Adjustment layers affect the appearance of all of the layers below them and don't actually change the content of those layers—remove an adjustment layer, and the image below returns to its previous state. As a layer, you can move it in the layer stack, and you can vary its opacity.

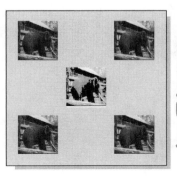

RESULT

PROCEDURE 7: PATTERN YOUR PHOTO

1. Select the upper-left photo.
2. From the **Layer** menu choose **New Fill Layer, Pattern.**

 Fill layers are used to fill selected areas with a color, pattern, or gradient.

3. A New Layer dialog box appears. Click **OK.**

4. A Pattern Fill dialog box appears. Pick an interesting pattern from the drop list, then click **OK.**

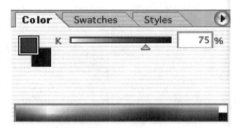

5. The pattern blocks out your photo. From the color palette, set the one slider to a value of about **75%.**

 The color palette now has only one slider showing a range of gray. The layer you are currently working on is the Pattern Fill layer. These types of layers have *Masks*, which are grayscale images that Photoshop uses to keep track of where this layer has effect. When you first make these layers, Photoshop makes the currently selected area white on the mask, which is its way of noting that the layer has full effect there. The rest of the mask is black, meaning that the layer has no effect there. (You can see a thumbnail of the mask on the layers palette).

6. Get the **Brush** tool, set it to a **9** point brush, and scribble quickly across your image. You will start to see your photo peeking through the pattern wherever you scribble. When you scribble beyond the edge of your photo, you will start to see the pattern overlapping the backdrop color.

 You are painting the mask gray (you can't see the mask on the screen but look at the thumbnail of it on the layers palette). The layer has partial effect where a mask is gray. The darker the gray, the less effect it has.

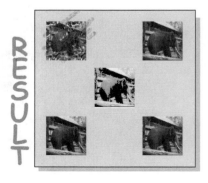

RESULT

PROCEDURE 8: HIDE BEHIND AN INVISIBLE CORNER

1. Use the **Magic Wand** tool to select everything *but* the photo on the layer with the upper-right photo.
2. From the **Layer** menu choose **Add Layer Mask, Hide Selection.**

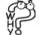 Just as adjustment layers and fill layers have masks, normal layers can also have them. This command creates a mask where the selected area is black, so the layer's image has no effect there: the pixels cannot be seen. The rest of the mask is white so the rest of the pixels from this image can be seen. You have just hidden areas of the layer that were already transparent but you will see the point of it in a couple of steps.

3. There are now two thumbnails on the layer's entry on the layers palette: a thumbnail of the image and a thumbnail of the mask. Between the two thumbnails is a chain symbol. Click this symbol and the chain disappears.

That symbol showed that the image was linked to the mask. If you moved the image, you also moved the mask. You can move the image without moving the mask by eliminating the link.

4. Click on the layer's image thumbnail to select the layer.

When you created the mask, the mask was automatically selected rather than the image.

5. With the **Move** tool, drag the photo down and to the right. The mask hides everything below and to the left of where the photo originally was. Stop dragging when about half of the image is still visible.

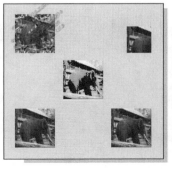

Procedure 9: Dissolve a photo

1. Select the layer with the lower-right photo.

2. On the layers palette, set the **Opacity** value to **70%**. The photo becomes translucent.

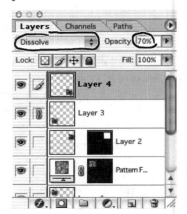

3. Click on the **Blending Mode** drop list and select **Dissolve.** The appearance of the photo changes. Instead of all the pixels being translucent, 70% of them are totally solid, while 30%—randomly scattered about—become totally transparent.

4. Save the file.

A DEEPER UNDERSTANDING: BLENDING MODES

Blending modes are used both with layers and painting tools to set how the color you are adding affects the appearance of the existing color beneath. *Normal* mode is the easiest to understand: this layer's image or this stroke of paint covers the ones below, and if you lower the opacity, it just mixes in with the colors below. You see here how Dissolve also covers the lower images.

The rest of the blending modes don't add your current layer or paint stroke to the image, but rather use the pixels of the image as a guide to adjust the appearance of the existing pixels. For example, *soft light* mode makes it look as though your layer image or paint stroke is one slide in a slide projector being projected on the image below. *Darken* checks each pixel and displays whichever is darker: the color of the underlying image, called the *base color*, or the color of the current layer or paintstroke you are adding, called the *blend color*.

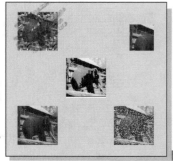

The best way to get a sense of what each blending mode does is to overlap two photographs—pick ones with a range of color—then try different blending modes for the upper layer. While doing this, experiment with different opacity settings.

RESULT

PROJECT 7

DANGEROUS METAL PIPE

CONCEPTS COVERED

- ❑ Using the grid
- ❑ Transforming shapes
- ❑ Editing shapes
- ❑ Naming layers
- ❑ Duplicating layers
- ❑ Restacking layers
- ❑ Creating styles
- ❑ Saving styles

REQUIREMENTS

- ❑ None, unless you're very scared of pointy metal objects, in which case you may need a calming cup of cocoa

RESULT

- ❑ A picture of a shiny tube with burrs on one edge

PROCEDURES

1. Turn on the grid
2. Make the rim
3. Tilt the rim
4. Copy the rim
5. Pick some anchor points
6. Extrude the pipe
7. Add the points
8. Color the pipe
9. Fill the hole
10. Reveal and color the rim

Procedure 1: Turn on the Grid

1. Open a new white image, 5 inches × 5 inches.

2. From the **View** menu choose **Show, Grid.** A gridwork of lines appears on your image. These lines aren't actually a part of your image—it's more like looking at your image through a screen door. This grid can be very useful in lining things up.

 To adjust the spacing and color of the grid, go to the Macintosh **Photoshop** or Windows **Edit** menu and choose **Preferences, Guides, Grid & Slices.**

3. Pull down the **View** menu. If there is no check mark next to the **Snap** command, choose that command.

 The check mark means that the snap feature is on. This feature automatically adjusts things you are drawing or dragging so that they adhere to gridlines, the edges of the images, and other vital points when you pass fairly close to these points. It makes it easier to create precisely placed items. When your pointer moves close to a gridline it "snaps" to the grid.

4. Also on the **View** menu check the **Snap To** submenu. If there is not a check mark next to **Grid,** choose it.

PROCEDURE 2: MAKE THE RIM

1. Set your foreground color to light gray.
2. Choose the **Ellipse** tool (shortcut: **u**) and reset the tool.
3. Click the **Geometry Options** drop button on the tool option bar.

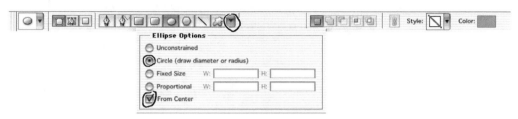

4. Select the **Circle** and **From Center** options so that when you use the ellipse tool, it will draw only perfect circles and treat the point that you start dragging as the center of the circle rather than a corner of a box that the circle fits in.

 You can easily get the same effect with the following options. Hold down **Shift** while you drag the ellipse tool, and it will draw a perfect circle. Hold down the Macintosh **Option** key or the Windows **Alt** key *after* you start dragging, and the point you started dragging will be considered the center. (If you hold it down before you start dragging, Photoshop thinks you want to use the eyedropper tool instead of the ellipse tool.)

5. Point to the centermost intersection of the grid then drag out a circle that goes about a half inch from each edge of the image area.
6. Click the **Subtract from shape area** button on the option bar.
7. Point to the center most intersection of the grid then drag out a circle that goes about a full inch from each edge of the image area.

 Now you see why snapping to the grid is useful: it makes it easy to draw two circles with the same center point.

PROCEDURE 3: TILT THE RIM

1. From the **Edit** menu choose **Transform Path, Perspective.** A box with sizing handles appears around the path.

 If you are experimenting with other commands while working on this project, Photoshop may have forgotten that you are working with a shape. If the Transform Path command is grayed out, choose the **Path Component Selection** tool (shortcut: **a**) to show that you are ready to deal with the shape. You can then select the command.

2. Drag the upper-left sizing handle to the right. As you drag it, the upper-right sizing handle automatically mirrors the motion, moving left. Drag until the upper edge of the box—now a trapezoid—is half the size of the lower edge.

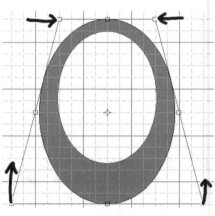

 Transforming a path works the same way as transforming a pixel picture as seen in Project 5, Procedure 2.

3. Drag the lower-left corner up. As you do, the upper-left corner lowers to meet it. Drag to the point where the circle is about one-inch high. Stop on one of the horizontal lines of the grid.

4. Repeat step 5 for the lower-right corner. Stop on the same line of the grid. Your circle will now be in perspective as if you had tilted it away from you.

5. Double-click inside the boxed area. This finishes the transformation.

 If you are ever in the middle of a transformation and decide not to carry it out, either click the **X** button on the right end of the option bar or press the **Esc** key.

6. Use the **Move** tool (shortcut: **v**) to drag the circle to half an inch from the top of the image.

RESULT

PROCEDURE 4: COPY THE RIM

1. You are done with the grid now so go to the **View** menu and choose **Show, Grid** to turn the grid off.

2. Click the arrow button on the layers palette and choose **Layer Properties** from the menu that appears.

3. In the dialog box that appears, type **Pipe Rim** then click **OK**.

 Naming your layers is not that important when you have just two or three, but it is a good practice to get into. When you have 30 layers, you will be glad you have the different names to tell them apart.

4. Click the arrow button again and choose **Duplicate Layer** from the menu. A dialog box appears.

5. Type **Pipe Body** as the name for the new layer then click **OK**. A new layer is generated with a copy of the same shape. You won't see any change in the image because the new shape is right on top of the old one.

. .

A DEEPER UNDERSTANDING: VECTOR PATHS

The shape you are developing here is a *path,* which means that Photoshop doesn't keep track of it as a grid of pixels, but rather as a set of points (called *anchors*) and the lines or curves that connect those anchors. If painting with pixels is like using a Lite-Brite® toy (sticking different-colored pegs into fixed positions on a grid), then building a path is like making string-art (hammering nails into a board, then wrapping string around the nails).

Because paths are this way, they can be resized, warped, and otherwise manipulated and still retain their sharpness. Enlarge a circle path, and you get a big circle. Enlarge a circle made of pixels, and you find that your circle has blocky edges.

RESULT

PROCEDURE 5: PICK SOME ANCHOR POINTS

1. From the toolbox, choose the **Path Component Selection** tool (shortcut: **a**) and click it on the outer rim of the circle. Four squares appear around the edges. Those are the *anchors* for the outer-rim shape. That circle is defined by those four points, and by how the curves connect them.

2. From the toolbox choose the **Add Anchor Point** tool (there is no shortcut for this one).

 Be careful: the icon for the Add Anchor Point tool is very similar to other tools that share the same button. Choose the one with the plus sign next to the pen nib.

3. Click on the outside rim of the circle, just below the anchor on the left-hand side. A new anchor point is added, which is connected to the left anchor and the bottom anchor of the circle.

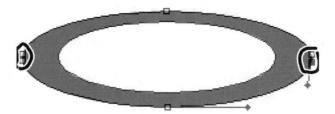

 If your pointer is an arrow, you're pointing at the wrong place. The pointer becomes an arrow when you aren't pointing to the edge of a shape, or when you're pointing to an existing anchor point. When you point to a blank spot on the rim, the pointer looks like the image on the tool button.

4. Repeat step 3 on the right side of the circle.

A DEEPER UNDERSTANDING: USES OF PATHS

Paths are good for more than just drawing shapes to appear on your image. A path can be used to create a selection area or a *clipping path* (which works like a mask, choosing what portions of a layer are displayed). Any path can be saved as a *custom shape*, which means that you can put it on other drawings almost as easily as you put rectangles or ellipses on. All the pen tools, such as the ones on the same button as the Add Anchor Point tool, are used to work on paths, and the shape tools, such as ellipse, rectangle, and so on, can work on paths or on pixels.

PROCEDURE 6: EXTRUDE THE PIPE

1. Go to the toolbox and get the **Direct Select** tool (shortcut: **a**).

 This tool is used to select and manipulate individual anchor points.

2. The anchor you added on the right side of the circle should look like a solid square rather than just an outline. This means that it is selected. If the square is just an outline, click on it to select it.

3. While holding down the **Shift** key, click on the anchor you added on the left side of the circle then on the anchor at the bottom of the circle.

 Holding down the shift key while selecting indicates that you want to select these items *in addition* to the items that you already have selected. (This is true not only for this tool or even for this program, but in most programs where you can select anything.)

4. Drag the bottom anchor point straight down to about an inch above the bottom of the image. When you do this, all three selected points move down, and the line connecting the original side-of-the-circle anchors and the new ones you added elongates so that everything is still connected.

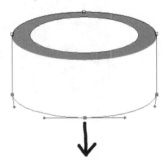

 After you start dragging, hold down the **Shift** key. When you do this, Photoshop will act as though you are dragging straight down from the starting point, even if your hand is not steady. (*Do not* hold down the shift before you drag, or Photoshop will think you are still selecting and deselecting anchors.)

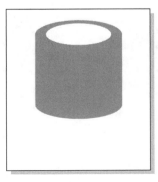

RESULT

PROCEDURE 7: ADD THE POINTS

1. Click a blank part of the image to deselect the currently selected points.

2. Select the anchor on the low center part of the shape.

3. A line with a handle on either end of it passes through that anchor. Drag the right handle upward about an inch. This turns the bottom edge of the shape into a wave, as if perhaps it were not just a simple slice of a pipe but maybe a broken-off end.

 These handles are used to set the angle of the line coming into and out of the anchor point. Photoshop figures out the shape of the curve connecting two anchors by looking at the angle the line has coming off of one anchor and the angle onto the next.

4. Using the technique shown in Procedure 5, add 11 anchor points along the bottom edge.

5. Using the direct selection tool, drag the third anchor of the bottom edge down about a quarter inch.

6. Repeat step 4 for every third anchor across the bottom.

7. From the toolbox, choose the **Convert Point** tool.

8. Click this tool on each anchor you dragged down. The points become pointy.

 The convert point tool changes the anchor from being a curve anchor, which the line passes through smoothly, to being an angle anchor, where the line changes direction at a sharp angle.

RESULT

PROCEDURE 8: COLOR THE PIPE

1. From the **Layer** menu choose **Layer Style, Gradient Overlay.**

 The **Add layer style** button on the layer palette also sets styles

2. On the Layer Style dialog box that appears, click the arrow button at the end of the gradient field. On the display of gradients that appears, click the arrow button in the upper-right corner and choose **Metals** from the menu that appears.

 This adds gradients that look like shiny metal to your list of gradients.

3. A dialog box asks you if you want to replace the current gradients. Click **Append.**

4. Click on a gray metallic gradient.

5. Make sure the **Style** drop menu is set to **Linear,** and set the angle to **6** degrees.

Drag across the image at this point to adjust where the gradient's highlights fall.

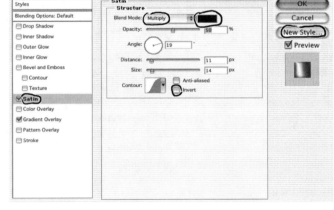

6. Click the word **Satin** in the Styles area of the dialog box. The satin style highlights some edges of the shape, and the Satin options appear.

7. Make sure the **Blend Mode** drop list is set to **Multiply,** that the color beside it is black, and that the **Invert** option is not checked.

Experiment with the other options. If Preview is selected you should see quickly what effect they have.

8. Click the **New Style** button.

9. In the New Style dialog box, name the style, **Pipe shine** then click **OK.**

 This saves the gradient-and-satin combination for reuse later.

10. On the Layer Style dialog box click **OK.**

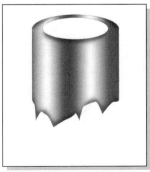

RESULT

PROCEDURE 9: FILL THE HOLE

1. Copy the current layer as seen in Procedure 4. Name the new layer **Hole.**
2. Get the **Path Component Selection** tool (shortcut: **a**) from the toolbox.
3. Click in the open oval of the shape. The oval becomes selected.
4. Press the **Delete** key. The open oval disappears, leaving a solid shape.
5. From the **Layer** menu choose **Layer Style, Satin.**
6. In the Layer Style dialog box, click the **Invert** option checkbox, then click **OK.**

 Satin normally creates a lighter object with darker edges. This will turn it into a darker object with lighter edges, giving you the dark look you need for the pipe's interior.

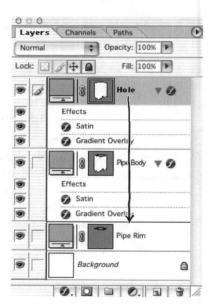

7. On the layers palette, drag the entry for the **Hole** layer below the entry for the **Pipe** body layer. The Hole layer will now be below the Pipe body layer; the only visible part of it will be the dark area visible through the hole.

 Each layer entry may have a list of that layer's style effects underneath it. You have to drag it to the dividing line between the bottom of the effects list and the top of the entry for the next layer.

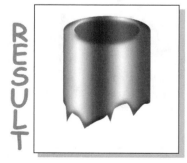

RESULT

PROCEDURE 10: REVEAL AND COLOR THE RIM

1. Select the **Pipe Rim** layer on the layers palette.
2. Drag the **Pipe Rim** layer to the top of the layer stack.
3. Open the styles palette.

 If you do not see the styles palette, go to the **Window** menu and choose **Styles.**

4. Click on the entry for the **Pipe shine** style you created. It is probably at the very bottom of the styles list. This style is now applied to the pipe rim.

When you hover your pointer over a style on the list, the name of that style appears. If you are only seeing names on the list and no pictures of the styles, click the arrow button in the upper right of the list and choose **Small Thumbnail.**

5. Save your file.

A DEEPER UNDERSTANDING: STYLES

The styles on the styles palette are just preset combinations of layer styles. They make it easy to quickly give a shape layer a specific look. Clicking the white box with the red slash through it quickly clears all the styles from the current layer. If you click the arrow button on the upper right of the styles palette, the menu that appears lists some other sets of styles ready for use.

That menu also has a **Save Styles** command, which will save all of the currently open styles in a new file. However, most of those styles were already stored somewhere else. If you want to save just the styles you created during this session, drag the other styles into the little garbage can at the bottom of the palette, then do the save. You can then get the other styles back by going to the menu and choosing **Reset Styles.**

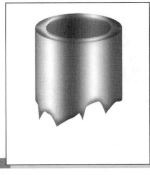

RESULT

PROJECT 8
DOTTY IMAGES

CONCEPTS COVERED

❑ Creating action folders
❑ Recording actions
❑ Adding action stops
❑ Playing actions
❑ Batch processing
❑ Color halftone filter

REQUIREMENTS

❑ Three Photoshop image files, at least one of which has layers

RESULT

❑ A batch process that automatically converts images into patterns of circular dots as in the photos in older newspapers

PROCEDURES

1. Start recording the action
2. Resize the image
3. Build the dot pattern
4. Pause for text
5. Finish recording
6. Replay the action
7. Batch the action!

PROCEDURE 1: START RECORDING THE ACTION

1. Move the image files you made from at least three of your previous projects to the same directory. Include at least one image with multiple layers, such as the dangerous-looking pipe from the previous procedure.

2. Open the image with multiple layers.

3. On the actions palette click the **Create new set** button which looks like a folder.

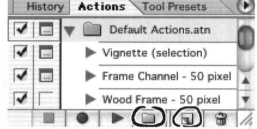

 If you do not see the actions palette, go to the **Window** menu and choose **Actions.**

4. A dialog box appears. Type in your name then click **OK.**

 This is the name for your own set of recorded processes. Giving them your name, will enable you to quickly find the ones that you created, as opposed to the ones that came with Photoshop and the ones that anyone else may have created on your machine.

5. On the actions palette click the **Create new action** button to tell Photoshop that you are about to build a brand new process. The button looks like a sheet of paper with a bent corner.

6. A New Action dialog box appears. Type **Make it dotty** to give the process a name then click **Record.**

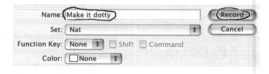

Photoshop is now set up to record your actions.

A DEEPER UNDERSTANDING: ACTIONS

An *action* is a recorded series of steps that have been performed on an image. By recording this series, you can perform an action on other images simply by invoking the action. This saves a lot of repetitive effort in graphics production. Actions are good in situations where there is no thinking involved. You can build actions just for regularly used short efforts, such as an action to reduce an image by half and flip it horizontally, or for full-length procedures.

RESULT

PROCEDURE 2: RESIZE THE IMAGE

1. From the **Image** menu choose **Image Size**. A dialog box appears.

2. Make sure the **Resample Image** option is selected then type **300** into the **Resolution** field. If the number 300 is already in the Resolution field, set it to **600,** continue through step 3, then repeat steps 1 through 3, setting **Resolution** to **300.**

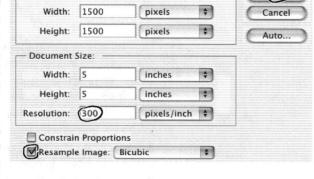

 If your image was 300, Photoshop won't record you setting it to 300 because it knows that isn't a change. But you need it to record setting an image to 300 so it knows to change all the other images to 300. Change it to 600 then to 300 and both changes are recorded.

3. Make sure the Resolution units drop menu says **Pixels/inch** then click **OK.**

4. From the **File** menu choose **Automate, Fit Image.** A dialog box appears.

5. Enter **600** into the **Width** field and **900** into the **Height** field then click **OK.**

 This tells Photoshop that the image should be proportionately resized so that it is exactly 600 pixels wide (2 inches at 300 pixels per inch) *unless* the resulting image should be more than 900 pixels (3 inches) high, in which case the image will be resized to 900 pixels high.

A DEEPER UNDERSTANDING: FIT IMAGE

The *Fit Image* command is one that you would never need if you were working by hand. You would use the **Image Size** command to set the width you want and be able to see if that would make the image taller than you can use. However, when building an automated system, you have to tell the computer your sizing rules so that it can make that decision on its own.

RESULT

PROCEDURE 3: BUILD THE DOT PATTERN

1. From the **Image** menu choose **Mode, Grayscale.** This tells Photoshop to convert the image from a color image into an image made up of black, white, and shades of gray.

2. A dialog box asks you if you want to flatten the image before the mode change. Click **Flatten.**

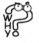 *Flattening* is reducing the image to a single layer. After it takes place, the image no longer has any shape information, layer styles, or other similar complexity. It is just one background image. This can be necessary if you want to perform actions that alter the whole image rather than individual layers. It is also more disk-space efficient. I asked you to use an image with layers specifically so you would have to answer this question. Had you created an automated procedure around a background-only image, you would not have had to answer whether to flatten it. Then you could not be sure what your recorded action would do if you ran it on a layered image.

3. From the **Filter** menu choose **Pixelate, Color Halftone.** A dialog box appears.

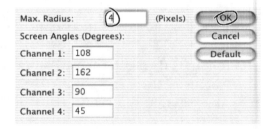

4. In the **Color Halftone** dialog box, enter **4** into the **Max. Radius** field then click **OK.** The image converts into a grid of equally spaced black dots. The dots are very small where the image is light gray, leaving much surrounding white area. However, the dots are big where the image is dark, so that area contains more black than white.

RESULT

PROCEDURE 4: PAUSE FOR TEXT

1. Click the arrowhead button on the upper-right corner of the actions palette. Choose **Insert Stop** from the menu that appears.

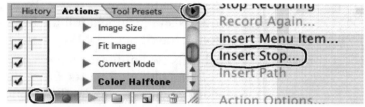

 You are about to add a label to this image describing what it is. Obviously, not every image you run this program on will be a dangerous-looking pipe, so you don't always want to add the same words. Marking that the action should stop here causes this action to pause when you run it so you will have a chance to add text. Restart the action to finish the rest of the steps.

2. A dialog box appears. Enter **Type in the text now, good-lookin'!** into the **Message** field then click **OK**.

 When the action pauses for this stop, it displays this message to remind you of what the stop was for.

3. Click the **Stop Playing/Recording** button on the actions palette. (This actually stops the recording; the previous steps just cause a pause during playback.)

4. Use the **Horizontal Type** tool to add some descriptive text in black over your image as shown in Project 3, Procedure 5.

5. Click the **Begin Recording** button on the actions palette to resume recording.

6. From the **Layer** menu choose **Layer Style, Outer Glow.**

7. In the Layer Style dialog box, make sure the glow color is white. Set the **Size** field to **10** pixels then click **OK.**

 The white glow helps make the black letters show up even against a dark background.

PROCEDURE 5: FINISH RECORDING

1. From the **File** menu choose **Save As.** If the dialog box that opens up doesn't include a full file browser, click the down arrow button at the right of the Where field to make one appear.

2. Click **New Folder** to create a new folder. Name it **Results.** From the **Format** menu choose **TIFF** and clear the **Layers** check box.

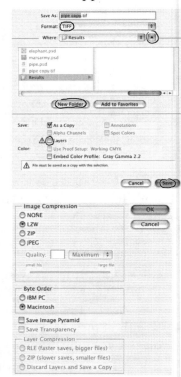

 The word *copy* is added to the file name so you don't confuse this flattened version with a version that still has multiple layers.

3. Click **Save,** and a dialog box appears asking you questions about what variation of file format you want to save in. Set **Image Compression** to **LZW,** set **Byte Order** to either **IBM PC** (if you are using a Windows machine) or **Macintosh** (if you are using a grilled cheese sandwich), and click **OK.**

4. From the **File** menu choose **Close** to close the image. When asked if you want to save your file, click **Don't Save.**

5. Click the **Stop Playing/Recording** button on the actions palette.

A DEEPER UNDERSTANDING: TIFF FILES

The *Tagged Image File Format (TIFF)* is a popular format for graphics for print publication (all images in this book were stored as TIFF files.) It doesn't degrade the image the way JPEG files do and it doesn't have GIF's color limitations, but almost any graphics program can read it. If your images are sent to a commercial press, avoid the LZW Compression option, because although most programs understand this disk space-saving scheme, it wreaks havoc with some commercial printing systems. Similarly, you always want to discard layers when preparing for commercial printings, because commercial printers cannot always handle images that haven't been flattened.

PROCEDURE 6: REPLAY THE ACTION

1. Open one of the other files in the folder.
2. On the actions palette click on the entry **Make it dotty**.

 If you can't find this entry on the list, click the triangle next to the entry with your name on it. Doing this opens and closes the list of actions in the folder.

3. Click the **Play Selection** button on the actions palette. Photoshop runs through the procedure, resizing the image, turning it grayscale, and flattening it. Then a dialog box pops up, telling you that it is time to add text.
4. Click **Stop** on the dialog box then use the **Type** tool to add type.
5. Click the **Play Selection** button again. Photoshop continues the procedure where it left off, adding the glow to the text, saving the file as a TIFF in the Results directory, and closing the image.

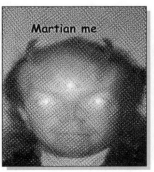

PROCEDURE 7: BATCH THE ACTION!

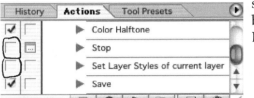

1. On the action palette, under the **Make it dotty** entry, is a list of steps that make up that action. Clear the check boxes to the left of the steps marked **Stop** and **Set Layer Styles of current layer.**

 When using batch mode to process a bunch of files through an action, Photoshop cannot handle Stop commands. Because of this, you can't use the batch mode to do things that are specific to each image. By clearing the check marks, you are saying "forego these steps!" In this case, the steps are stopping for text and adding a glow to the text.

2. If you want to keep the two images you have already created in the project, move them from the folder to somewhere else. (Otherwise, they will be overwritten with textless versions.)

3. From the **File** menu choose **Automate, Batch.** A Batch dialog box appears.

 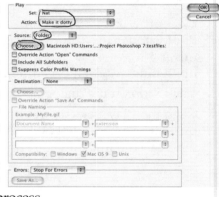

4. Your name should be selected on the **Set** drop list, and **Make it dotty** should be selected on the **Action** drop list. Set **Source** to **Folder** then click **Choose.**

5. Use the file browser that appears to select the folder with all the files you want to process.

 This is a bit confusing. You don't want the file browser to display the *contents* of the folder that has your files. Instead, it should display the contents of the next file up in the hierarchy. Click, but don't double-click, on the name of the folder you want then click **Choose.**

6. Click **OK,** and watch as Photoshop converts your images. It may get stuck on some images, asking whether you want to rasterize the type or other such changes. Click **OK** for these.

7. When all of the images are done, click the actions folder with your name on it, then click the arrow button in the upper right of the actions palette, and choose **Save Actions** from the menu that appears. A file browser opens. Click **Save.**

PROJECT 9

ANIMATED ADVERTISEMENT

CONCEPTS COVERED

❏ Switching to ImageReady
❏ Animating
❏ Inserting frames
❏ Loading swatches
❏ Text palette
❏ Turning off visibility

REQUIREMENTS

❏ Kindly thoughts about bananas

RESULT

❏ An animated advertising banner ready for use on the Web

PROCEDURES

1. Get the right color swatch
2. Add some text
3. Draw an apple
4. Add a second display
5. Switch programs
6. Create key frames
7. Fade in the text
8. Throw the apple
9. Animate the rest
10. Save the animation

PROCEDURE 1: GET THE RIGHT COLOR SWATCH

1. Create a new image in **RGB Color** mode using the **Preset Sizes** menu to choose **468 × 60 Web banner**.

 Although Web advertising comes in a variety of sizes, the 468 × 60 pixel banner is the most common size.

2. Open the **Swatches** palette. This palette shows an array of fixed colors so it is easy to select.

DIC Color Guide
FOCOLTONE Colors
HKS E
HKS K
HKS N
HKS Z
Mac OS
PANTONE metallic coated
PANTONE pastel coated
PANTONE pastel uncoated
PANTONE process coated
PANTONE solid coated
PANTONE solid matte
PANTONE solid to process
PANTONE solid uncoated
TOYO Colors
TRUMATCH Colors
VisiBone
VisiBone2
Web Hues
Web Safe Colors
Web Spectrum

 If you do not see this palette, go to the **Window** menu and choose **Swatches.**

3. Click the arrow button on the upper right of the swatches palette, and choose **Web Safe Colors** from the list that appears. If a dialog box asks if it's okay to replace colors, click **OK**.

 Some people browse the Web on devices that only show 256 colors at a time. Web browser manufacturers have standardized a set of 216 *Web safe* colors, which all color Web browsers should display well. Those 216 colors are now displayed on your swatches palette.

4. Click a bright yellow square on the swatches palette. This yellow becomes your foreground color.

To set the background color using the swatches, hold down the Macintosh ⌘ key or the Windows **Ctrl** key while you click on a color.

5. Use the **Paint Bucket** tool (shortcut: **b**) to fill the image's background with yellow.

RESULT

PROCEDURE 2: ADD SOME TEXT

1. Click on the color black on the swatches palette.

 You will find black at the very end of the color display.

2. Choose the **Horizontal Type** tool (shortcut: **t**).

3. On the option bar, set the **Anti-aliasing method** drop list to **None** then click the **Toggle the Character and Paragraph palettes** button.

Anti-aliasing smooths diagonal lines and curves by making small adjustments to the colors of the edge pixels. In a GIF file, those extra colors make the file larger. On the Web, larger means *slooower*.

4. On the character palette, set the **font family** to **Impact** and the **font size** to **18.**

5. Drag the **Horizontal Type** tool to create a text box that is the full width of the image and takes up the top half of its height. Type **An apple a day keeps the doctor away** into this box.

6. From the **Select** menu choose **Select All** to select the text you typed.

7. Increase the **Horizontally scale** value on the character palette and you will see the letters get wider. Find a value that makes the phrase so wide that it almost reaches from one side of the image to the other.

8. Click the **Create a new layer** button on the layers palette to make a new text layer.

9. Repeat this process to put the phrase **only if the doc fails to duck** in the bottom half of the image.

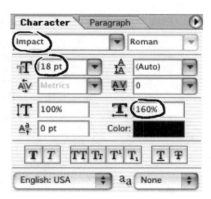

When you are done, use the **Move** tool (shortcut: **v**) to adjust the text placement.

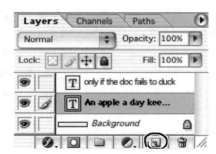

PROCEDURE 3: DRAW AN APPLE

1. Click the eye symbol on the layers palette entry for the **only if the doc fails to duck layer**. The phrase disappears.

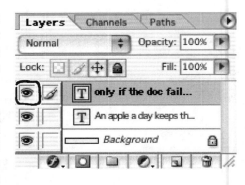

 This eye symbol indicates that the layer is visible. Click it away and the layer is still part of your image, but an invisible part. Making this invisible now gives you some visually uncluttered room to work on the next part of the image.

2. Choose the **Ellipse** tool (shortcut: **u**) and reset the tool to make sure that the **Create new shape layer** option is selected.

3. Draw a red ellipse, perhaps a third of the image's height and about a third thinner than it is high, toward the left edge of your image.

4. Choose the **Move** tool (shortcut: **v**) and hold down the Macintosh **Option** or Windows **Alt** key as you drag that ellipse. This causes a copy of the ellipse to appear; what you are dragging is the copy. Drag it to the right and release it when the left edge of the copied ellipse is at the center of the original ellipse. The two ellipses should now look like the body of an apple.

 If the ellipse jumps to the bottom of your image, go to the **View** menu, choose **Snap**, then drag it back into place.

5. Click the **Create a new layer** button on the layers palette.

6. On the new layer use the **Pencil** tool (shortcut: **b**) to draw a black stem on the apple.

7. Link the stem layer to the two apple ellipse layers as shown in Project 6, Procedure 4.

8. From the layer menu choose **Merge Linked.** The ellipse layers and the stem layer combine to make a single raster layer with the image of an apple.

9. Make the invisible layer visible again by clicking back in the same location.

RESULT

An apple a day keeps the doctor away
Only if the doc fails to duck.

PROCEDURE 4: ADD A SECOND DISPLAY

1. Click the **Create a new layer** button on the layers palette.
2. Use the **Paint bucket** tool (shortcut: **g**) to flood the new layer with black.
3. Reselect the yellow you used before.

 Instead of trying to find the exact same color on the swatches palette, just make the new layer invisible. Click the **Eyedropper** tool (shortcut: **i**) on the yellow background then make the new layer visible again.

4. Use the **Horizontal Type** tool to add the word **BANANAS** at the top of the image centered horizontally. The font should be set to **Times New Roman, Bold, 36 pt,** and the **Horizontally scale** value should be set to **200%.**

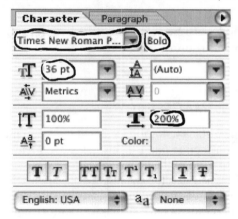

5. Add three more type layers, each with one word (**Fruit, with,** and **appeal**) in yellow, and set the font to **Impact, Regular, 18 pt,** horizontally scaled at **200%.**
6. Line up the three words under the word BANANAS.

 Space them horizontally by hand but use the system shown in Project 6, Procedure 5 to align their top edges to make sure they are vertically in line.

RESULT

BANANAS
Fruit with appeal

PROCEDURE 5: SWITCH PROGRAMS

1. Save your image.
2. *If* your system has at least 128 megabytes of memory, click the **Jump to ImageReady** button in the toolbox. Your image will now be opened in ImageReady. Skip the rest of the steps on this page.

 TIP If you don't know if your system has 128 megabytes of memory, click the button anyway. If the ImageReady program opens, then you should be fine.

3. If your system *does not* have 128 megabytes, go to the **File** menu and choose **Quit** to leave Photoshop.
4. Start up ImageReady. (It should be in the same folder as Photoshop.)
5. From the file menu choose **Open.** Use the file browser that opens to select and open the file you just saved.

..

A DEEPER UNDERSTANDING: IMAGEREADY

If this is the first time you have run Photoshop's companion program ImageReady, you will find it looks quite familiar. ImageReady is really just a version of Photoshop, with some of the tools and features eliminated and replaced with tools designed just for creating Web graphics. In fact, you could have created the entire project so far using ImageReady instead of Photoshop, but then I could not have shown you how to move an image from one to the other! ImageReady can create interactivity and animation while optimizing image download speed.

RESULT

BANANAS
Fruit with appeal

PROCEDURE 6: CREATE KEY FRAMES

1. Make all of the layers invisible except for the yellow background and the *An apple a day* text layer, using the layers palette technique shown in Procedure 3.

 This works the same in ImageReady as it does in Photoshop. If I tell you to do something that works differently, I will point out the difference.

2. On the animation palette is a miniature picture of your image. This is the first *frame* out of the many frames that will make up your animation. Click where it says **0 sec.,** and a menu appears. Choose **0.1 second** to set the amount of time this frame will appear on the screen.

 If you don't see the animation palette, go to the **Window** menu and choose **Animation.**

3. On the animation palette, click the **Duplicates current frame** button. Two miniature frames are now displayed on the animation palette.

4. Click on the first frame in the animation palette to select it.

5. Select the *An apple a day* text layer by clicking its entry on the layers palette.

6. On the layers palette, click the arrow button. If there is a check mark next to the **Propagate Frame 1 Changes** command, select that command.

7. On the layers palette, set **Opacity** to **0%.** This only changes the currently selected frame. Now the words are not visible on this frame but are fully visible in the next.

··

A DEEPER UNDERSTANDING: ANIMATION

A movie is really just a series of still pictures. Shown very quickly, the images appear to move.

Animation works in the same way, as a series of still images called *frames.* On a TV cartoon, master animators draw the first and last frames of each motion (say, Superman with his fist pulled back, and then Superman at the end of throwing a punch). Assisting animators, called *tweeners,* draw steps in-between, such as the fist in motion. In ImageReady, you design key frames, then the computer tweens.

PROCEDURE 7: FADE IN THE TEXT

1. With the first frame selected, click the **Tweens animation frame** button on the animation palette.

2. On the dialog box that appears, make certain that the **Opacity** option is checked and the **Tween With** drop list has **Next Frame** selected. Set **Frames to Add** to **8** then click **OK**.

3. ImageReady creates eight new frames, with the words growing more opaque in each consecutive frame. Click the **Plays/stops an animation** button and you can see your animation play in the main image window!

 If you select **Forever** at the far left end of the animation palette, the animation will keep playing until you press the **Plays/stops an animation** button again.

An apple a day keeps the doctor away

PROCEDURE 8: THROW THE APPLE

1. Select the last frame by clicking its image on the animation palette.

 You probably have enough frames now that the animation palette can't display them all at once. Use the scroll bar at the bottom of the palette to find the final one.

2. On the layers palette, find the layer with the image of the apple, select the layer, and make it visible.

3. Use the **Move** tool (shortcut: **v**) to drag the apple off the left side of the image.

 You can't just drag the apple directly off the edge because once you hit the edge of the image, the move tool stops working. Instead, make sure the **Auto Select Layer** option on the option bar is turned off, so you are dragging the current layer no matter where on the image the move tool is. Point to the center of your image and drag to the left. The apple will move.

4. Copy this key frame as shown in Procedure 6.

5. On the new frame, drag the apple until it is off the right side of the image. Remember, this frame starts as a copy of the previous frame, where the apple is off the left side, so you will have to drag the layer to the right a bit before you even see the apple.

6. Create five tween frames between these two key frames as shown in Procedure 7. If you test the animation now, the words fade in, then the apple flies across the screen.

 If the animation seems too slow or jerky, move your cursor. Sometimes, that will get the system rolling again.

RESULT

An apple a day keeps the doctor away

PROCEDURE 9: ANIMATE THE REST

1. In the last frame, use the layers palette to make the second text layer—*only if the doc fails to duck*—visible. Switch the layer's **blending mode** from Normal to **Dissolve**.

 With the mode set to Dissolve, the text will come in with pixels filling in suddenly instead of fading in.

2. Using the same method that you used for fading in the first line of text—duplicating the frame, lowering the opacity of the original frame, and tweening—fade in this line of text.

3. Set the timing on the last frame to **1.0** second.

4. Duplicate the last frame, and on the new frame make the all-black layer and the BANANAS text layer visible. Do not do any tweening from the previous frame.

 This change should happen suddenly rather than fading in or moving in. The timing on these frames is set to 1 second because they need to be on screen long enough to be read before the next thing happens.

5. Repeat step 4, making the *fruit* text layer visible. Repeat step 4 again for the *with* text layer, and finally for the *appeal* text layer. These words will appear in order, with a one-second rhythm between them.

6. On the final frame, set the blending mode for the all-black layer to **Dissolve**. Make the apple layer and the text layers with *An apple a day* and *only if the doc* invisible.

 It may seem silly to make those layers invisible because they are covered with the black layer anyway. But you are about to dissolve the black layer and don't want to see them.

7. Duplicate the final frame and set the opacity on the black layer on the new last frame to **0%**.

8. Tween in five frames, and set the timing on those frames to .1 second. The animation now starts and ends with yellow, repeating seamlessly.

RESULT

PROCEDURE 10: SAVE THE ANIMATION

1. If your animation is still running, *stop it!*

 Animation takes a lot of your computer's processor power, slowing everything else down.

2. From the **File** menu choose **Save** to save a copy of the Photoshop/ImageReady file.

 This version of the file has all the information about layers and settings that will come in handy if you ever want to edit this file again.

3. Go to the **File** menu again and choose **Save Optimized**. A file browser appears.

4. Give your file the name **bananas.gif,** set the **Format** drop list to **Images Only,** and click **Save.** A GIF version of your animation is now on your hard disk.

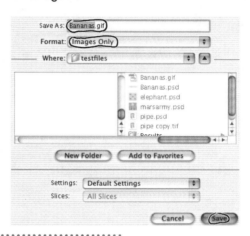

 You can look at this saved version any time you want by using your Web browser. Using its **File** menu, choose **Open** and use the file browser to find the **bananas.gif** file.

A DEEPER UNDERSTANDING: ANIMATION OPTIMIZATION

The bigger a file you have on the Web, the longer it takes to download. People do not like waiting for their Web pages to download, so graphic files are kept as compressed as possible.

Because of this, the GIF file doesn't have all the information about the layers and the opacity settings and the like. For the first frame, the GIF file has a picture of the contents of the frame. Our first frame is easy, because it is completely yellow. The GIF file doesn't have a full picture of the frame for each subsequent frame. Instead, it keeps track of the pixels in this frame only, which are different from the pixels of the frame before it. When the apple is flying, for example, a frame might be stored just as a picture of the apple where it is now and a yellow apple shape, which covers where the apple was in the last frame. The Web browser rebuilds each frame on-the-fly.

RESULT

PROJECT 10
A CLOUDY DESIGN

CONCEPTS COVERED

- ❏ Designing gradients
- ❏ Creating work paths
- ❏ Combining objects
- ❏ Stroking
- ❏ Selections from paths
- ❏ Airbrush capabilities
- ❏ History brush
- ❏ Art history brush

REQUIREMENTS

- ❏ None

RESULT

- ❏ A cloud design

PROCEDURES

1. Create a gradient
2. Fill the sky
3. Shape your cloud
4. Save your cloud
5. Stroke your cloud
6. Make a rain cloud
7. Make it rain

PROCEDURE 1: CREATE A GRADIENT

1. Create a new image, **450** pixels wide and **450** pixels high, in **RGB Color** mode.

2. Set the foreground color to white, and the background color to a rich blue.

3. Choose the **Gradient** tool (shortcut: **g**) from the toolbox, and reset the tool. It is important to reset the tool. (I mean it!)

4. A picture of a white-to-blue gradient is now on your option bar. Click on that gradient, *not* on the drop-list button at the end of the gradient! A gradient editor dialog box appears.

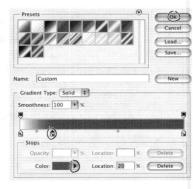

5. Click just below the wide gradient line, about one-fifth of the way from the left end. A pointer appears below the gradient line, noting where the gradient will reach a specified color.

6. Click the arrow at the right end of the **Color** field and choose **Background** from the menu that appears. This specifies the color for the point you set in step 5.

> **TIP** Photoshop doesn't change the gradient display immediately to show the effect of setting the color. Click the pointer you set and the change appears.

7. Repeat steps 5 and 6 for another point, another one-fifth of the way across, only choosing **Foreground** from the color field.

8. Repeat the process twice more, alternating between **Background** and **Foreground.** You will have six pointers along the bottom edge of the gradient, including the original two at the ends.

9. Click **OK.**

A DEEPER UNDERSTANDING: GRADIENT DESIGN

This gradient you created uses any current foreground and background colors. Changing the foreground color to red now gives you a gradient alternating between red and blue. To set a fixed color in your design, click on the **Color** field itself and use the color selector that appears to choose a color.

The points *above* the gradient line are used to vary the opacity of the gradient.

PROCEDURE 2: FILL THE SKY

1. Click the **Radial gradient** button on the option bar.

2. Drag from the upper-right corner of the image to the lower-left corner. When you release the mouse button, curves alternating from white to blue emanate from the upper-right corner.

3. Drag again, this time from the upper left to the lower right. The image is now filled with curves emanating from the upper left.

 It probably seems odd to have done step 2 when you just cover it up with step 3. Think of it as painting a new painting over an old painting. Later, you will scrape away some of that new paint to reveal the old paint underneath.

4. The bottom of your history palette should now list two gradient steps. Click the box to the left of the upper gradient step. A brush-with-an-arrow symbol appears in the box.

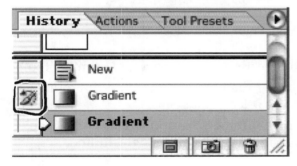

 This indicates what layer you are going to scrape the paint back to when you do scrape the paint. That symbol indicates that you will be scraping it back to what the image looked like after you dragged the first gradient.

PROCEDURE 3: SHAPE YOUR CLOUD

1. Choose the **Freeform Pen** tool (shortcut: **p**) from the toolbox and reset the tool.

 Be careful—this tool's symbol looks very much like the other tools that share its button position and its shortcut.

2. Click the **Paths** button on the option bar.

3. Use this tool to drag a bumpy cloud form, about one-quarter of the width of the image, and one-sixth the height. It doesn't matter where on the image you put it.

4. Choose the **Rounded Rectangle** tool (shortcut: **u**) from the toolbox. Make sure the **Add to shape path** button is pressed in on the option bar.

5. Drag the rounded rectangle into place so that it covers over the bottom half of the bumpy object you made.

 This gives the cloud a nice, flat bottom.

6. Choose the **Path Selection** tool (shortcut: **a**) from the toolbox.

7. Drag a box enclosing the bumpy object and the rounded rectangle. Both become selected.

8. Click the **Combine** button on the option bar. The two selected items meld into a single item with a single outline.

• •

A DEEPER UNDERSTANDING: WORK PATHS

You have just built a *work path*. You make a work path using the same tools you use for clipping paths and shapes. The difference is that the work path doesn't actually *do* anything to change your image immediately. You will use this work path to do different things later.

PROCEDURE 4: SAVE YOUR CLOUD

1. Click the arrow button on the upper right of the paths palette.

 If you do not see the paths palette, go to the **Window** menu and choose **Paths.**

2. From the menu that appears choose **Save Path.**

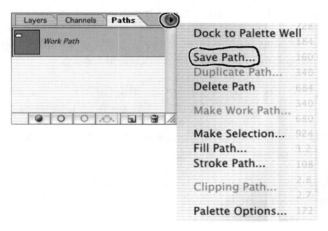

Saving this path enables you to get it back later on when working on this image. Otherwise, this one would be lost if you were to create another work path.

3. A dialog box appears. Type a name for this path (**Cloud** would probably be a fine name, although if you want to name it **Murgatroyd,** that is certainly up to you) then click **OK.**

RESULT

PROCEDURE 5: STROKE YOUR CLOUD

1. Choose the **History Brush** tool (shortcut: **y**) from the toolbox.

 TIP Be careful—this tool's symbol looks very much like the other tool that shares its button position and its shortcut.

2. On the option bar, pick the **9** pixel brush tip for this brush. Make sure the **Mode** is set to **Normal,** and **Opacity** is set to **100%.**

 WHY You are not about to use the brush directly, but you will be giving a command that will use the history brush's current settings.

3. Click the arrow button in the upper-right corner of the paths palette and choose **Stroke Path** from the menu that appears.

 WHY This command takes a brush and runs it around the path you have drawn so it will paint the cloud shape.

4. A dialog box appears, asking what type of brush you want to use. The history brush will already be selected so just click **OK.**

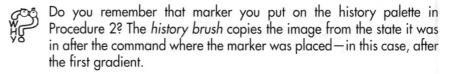 WHY Do you remember that marker you put on the history palette in Procedure 2? The *history brush* copies the image from the state it was in after the command where the marker was placed—in this case, after the first gradient.

5. The cloud edge now appears on the image. Use the **Path Selection** tool to drag the work path to another part of the image, then use the **Stroke Path** again to place another cloud.

6. Add more clouds in the same way but leave a space at least a cloud wide and two clouds high in one of the lower corners. You will put a special cloud there later.

R
E
S
U
L
T

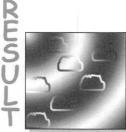

PROCEDURE 6: MAKE A RAIN CLOUD

1. Drag the path to the upper part of the area you left unclouded.

2. Click the arrow button in the upper-right corner of the paths palette, and choose **Make Selection** from the menu. A dialog box appears.

3. Set the **Feather Radius** to **10** pixels, then click OK.

 Feathering means fading something out at the edges. By setting a feather radius, you are saying that there is an area around the edge of the selection that you want partially selected—anything you do within that partially selected area won't be fully opaque. Doing this with a cloud creates lighter edges to the cloud, just like a real cloud. If you want a normal selection, just choose a zero pixel feathering radius.

4. The path turns into a selection marquee, but because of the feathering, it is not quite the same shape as the path. Set your foreground color to black.

5. Choose the **Brush** tool (shortcut: **b**) from the toolbox. Use the **17** pixel brush tip, with **Mode** set to **Normal, Flow** set to **25%**, and the **Set to enable airbrush capabilities** button pushed in.

 Airbrush capabilities means that the longer you keep the brush over an area, the more opaque the color gets. This makes it good for creating irregularly colored things, such as a storm cloud.

6. Scribble the brush across the selection until it is filled in. Don't scribble so much that the color is completely solid on the inside of the cloud. Some variation in color is good.

7. From the **Select** menu choose **Deselect** to clear the selection.

RESULT

PROCEDURE 7: MAKE IT RAIN

1. Choose the **Art History Brush** tool (shortcut: **y**) from the toolbox.

 🤖 Be careful—this tool's symbol looks very much like the history brush tool that shares its button position and its shortcut.

2. On the option bar, reset the tool. Set the **Brush** to **1** pixel and the **Style** to **Dab.**

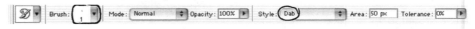

 🐛 The art history brush regresses the image to the state it was in at the step marked on the history palette. It doesn't reproduce that image precisely, however. Instead, it creates artistic brush effects, altering the source colors in various ways. The settings on the option bar set exactly how the effect is altered. (This is a fun set of options to experiment with.)

3. Start directly beneath the dark cloud and drag downward to create rain.

 🤖 Don't pause while dragging this brush. The effect will accumulate, creating solid blocks of dots rather than the stippled "rain" effect you want.

4. Save the file.

Project 11

Spooky Eyes

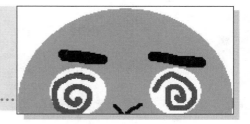

CONCEPTS COVERED

- ❏ User-created slices
- ❏ Creating rollovers
- ❏ Testing rollovers
- ❏ Previewing images

REQUIREMENTS

- ❏ A properly configured Web browser that supports Javascript (such as Netscape 2.0 or higher, Internet Explorer 3.0 or higher, or most other modern Web browsers). Without such a Web browser, you can still create the project. You just won't be able to test the results.

RESULT

- ❏ A face with eyes that detect and follow the pointer

PROCEDURES

1. Create a sleeping face
2. Add layers of eyes
3. Slice the face
4. Create a rollover
5. Test the rollover
6. Create more rollovers
7. Save face
8. Browse the results

PROCEDURE 1: CREATE A SLEEPING FACE

1. Start the ImageReady program (as discussed in Project 9, Procedure 5).

2. From the **File** menu, choose the **New** command. A dialog box appears.

3. In the **Name** field, type **face.** Set the **Width** to **200** pixels, the **Height** to **100 pixels,** and the **Contents of First Layer** to **Transparent,** then click **OK.**

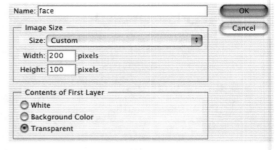

4. Set the foreground color to a skin tone. (Don't use absolute black, because we'll need black to contrast with it later. If you're still in a Martiany mood, use green!)

5. Choose the **Ellipse** tool (shortcut: **u**) from the toolbox.

> ImageReady has many of the same tools as Photoshop. However, the buttons are in different positions in the toolbox and some use different shortcuts.

6. Choose the **Create filled region** option on the option bar and clear the **Anti-aliased** check box.

7. Drag from an upper corner of the image area downward and toward the opposite side, so that the image is filled with the top half of a circle.

8. Set the foreground color to black.

9. Use the **Pencil** tool (shortcut: **n**) with a fairly thin point to draw in a pointed nose at the bottom center of the screen and two straight lines to either side to indicate closed eyes.

10. Use a thicker point to draw in some bushy eyebrows. Put them at least halfway up the image, so you have plenty of room to add big, wide-open eyes under them.

RESULT

PROCEDURE 2: ADD LAYERS OF EYES

1. From the **Layer** menu, choose **New, Layer** to create a new layer. (Name it **eyeballs.**)

2. Use the ellipse tool again to draw a couple of big, white eyes on this layer. They should be almost the entire distance from the bottom of the eyebrows to the bottom of the image, and they should be wide enough to cover up the closed-eye lines you drew.

3. Create another new layer and name it **look forward.**

4. On this layer, draw a couple of black pupils right in the center of the white eyes.

5. From the **Layer** menu, choose **Duplicate Layer.**

6. On the layers palette, double-click on the name of the newly duplicated layer (**look forward copy**). The name becomes highlighted. Type **look left** then press the **Return** or **Enter** key.

7. Use the **Move** tool (shortcut: **v**) to move this layer to the left, so that the pupils are at the left side of the eyes.

8. Duplicate another layer, rename it **look right,** and drag the pupils to the right of the eyes.

9. Duplicate another layer, rename it **look up,** and drag the pupils to the top of the eyes. (At this point, with four pupils in each eye, you have a Martian even if you didn't choose green skin!)

10. Make another new layer—not a duplicate—and name it **stunned.**

11. Draw some funny-looking pattern in the eye area as if you're drawing a cartoon of someone who has been punched. (I drew purple spirals in both eyes. Some people prefer drawing big stars, or multicolored waves.)

RESULT

PROCEDURE 3: SLICE THE FACE

1. Choose the **Slice** tool (shortcut: **k**) from the toolbox, and set the **Style** to **Normal** on the option bar.

 This tool divides the image into rectangular regions. You're setting it up so that the eyes will move toward the left when you point to the left part of the image, and to the right when you click the right part, etc. By dividing the image, you can show which area to consider the left part, which area to consider the right, and so on.

2. On the **View** menu, make sure that **Snap** and **Snap To, Slices** have check marks next to them. If either one does not have a check mark, select that command to place a check mark next to it.

 Turning on these features makes it easier to line up the edge of one slice of the image with the edge of another.

3. Drag a rectangle that includes all of the image from the bottom of the eyebrows up. When the user points to that part of the image, you want the eyes looking up.

4. Drag another rectangle that goes from the lower-left corner of the image to the bottom of the previous slice, with its right edge between the left pupil and the center pupil of the left eye. Dividing lines show the edges of each slice, with the current slice dis-

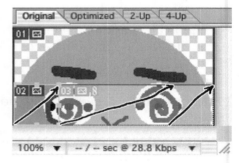

played in a different color with sizing handles. (If you don't see those lines, press **q**.)

5. Drag another slice like the last one, only on the other side.

6. Drag a final slice that covers the area between the two side slices.

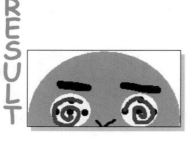

PROCEDURE 4: CREATE A ROLLOVER

1. On the layers palette, make all layers but the bottom one invisible by clicking on the little eye symbols on the left edge of the palette.

 You're choosing what you want to be the *normal* state, the way the image looks when the pointer isn't on it at all.

2. Choose the **Slice Select** tool (shortcut: **k**) from the toolbox.
3. Click on the upper slice to select it.

4. If the rollovers palette isn't open, go to the **Window** menu and choose **Rollovers**.

5. Click on the **Create rollover state** button. A new thumbnail appears, marked **Over State,** meaning that this state is how the image will appear when the pointer is over that part of the image.

6. On the layers palette, make the layers **eyeballs** and **look up** visible.

 The rollover system appears to create a different image for each *rollover state* such as an area of the image being pointed to, clicked on, and so on. Actually, it's always the same image made of the same layers—the difference is in the visibility of each layer as well as which layer styles are turned on.

7. Click the **Creates new rollover state** button again. The new state is **Down State,** which means this image is triggered when the pointer is over the slice and the mouse button is pressed down.

8. Make the **look up** layer invisible and the **stunned** layer visible.

RESULT

PROCEDURE 5: TEST THE ROLLOVER

1. Click **Toggle Slices Visibility** (shortcut: **q**) in the toolbox to hide the slice dividing lines.

2. Choose **Rollover Preview** (shortcut: **y**) from the toolbox. Because your pointer is not on the image now, it should be in its *normal* state, with the eyes closed.

3. Point to your image's forehead. The eyes should open up, with the pupils looking up. This is the *over* state for the forehead.

4. While pointing to the forehead, press down your mouse button. The stunned look of the *down* state should appear.

5. Move your pointer away from the image and it returns to its normal state.

6. Click the **Preview in Default Browser** button. Your Web browser opens, displaying the image. It also displays the source code for displaying the image.

 If you hold this button down, you can select which of your installed Web browsers will display the preview.

7. Repeat the testing steps listed above on the browser image.

Depending on your system and browser, pressing the mouse button down on the forehead might bring up a menu. Just point off the menu and click again.

8. Close the Web browser and return to ImageReady.

PROCEDURE 6: CREATE MORE ROLLOVERS

1. Click **Toggle Slices Visibility** (shortcut: **q**) in the toolbox to show the slice dividing lines.

2. Choose the **Slice Select** tool (shortcut: **k**) from the toolbox.

3. Click on the lower left slice to select it.

 You can also select slices by name in the rollovers palette.

4. Repeat the process from Procedure 4, except make the **look left** layer visible for the over state, instead of the **look up** layer.

5. Go through this again with the center slice, using the **look forward** layer.

6. Do this one more time for the right slice, with the **look right** layer.

7. From the **Select** menu, choose **Deselect Slices** to clear the selection.

. .

A DEEPER UNDERSTANDING: ROLLOVERS

Rollovers are simply graphics that change when you do something to them with the mouse. When you create a rollover image for a Web page, you aren't just creating a single-image file, you're creating a different image file for every rollover state. In this project, you actually create about 15 separate Web images, because each slice in each possible state is saved as a separate file.

ImageReady also creates an *HTML* page, which is the primary file that describes a Web page. A *Javascript* program is embedded in this HTML page. *Javascript* is a simple programming language that most Web browsers understand. This program tells the browser when to replace one image with another, creating the rollover effect.

If you keep clicking the button to create rollover states for a slice, you'll find four more possible states. In addition to the *over* and *down* states you've already seen, a rollover can be triggered by a *click* on the image, or by the pointer moving *out* from over the image, or by the mouse button being *up*. The *selected* state is triggered by clicking on the slide, but it is different from the click state because it doesn't cancel out states that other slices may have triggered.

RESULT

PROCEDURE 7: SAVE FACE

1. From the **File** menu, choose **Save.** The Save dialog box opens, with the name **face.psd** already suggested, so all you have to do is select a folder to save it in then click **Save.**

 This saves your image as a single file that you can edit later, but which cannot be read by Web browsers.

2. On the image window, click the **4-Up** tab. Four versions of your image are displayed, each compressed using GIF compression with slightly different settings. This way you can pick which compression you want to save with. In this case, it doesn't really matter because they all end

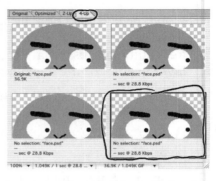

up looking the same and being the same file sizes (except for the one in the upper-left corner, which is uncompressed and creates bigger files). Click on the lower right image.

 When you have a picture with a lot of colors, the compression option can really make a difference in image quality and download speed. You can set the compression settings for each of the displayed versions using the optimize palette.

3. From the **File** menu, choose **Save Optimized As.** Using the file browser that appears, select a location for your files, and make sure the **Format** is set to **HTML and Images** then click **Save.**

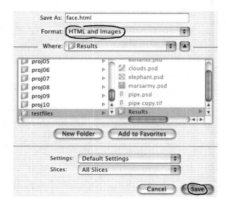

 This save stores the HTML file, which describes the page to Web browsers. It also creates a folder named **Images** and stores all the graphic files in it. The HTML file can be edited using any standard HTML file editor to build a whole page around the image, or portions of the file can be copied into an existing HTML page.

PROCEDURE 8: BROWSE THE RESULTS

1. Start up your Web browser.

2. Pull down your Web browser's **File** command, and choose **Open** or **Open File** or **Open Page,** whichever is there.

3. Your Web browser will either present a file browser or show a field for the file name with a **Choose File** button. Click that button if it's there, and you'll get a file browser.

4. Use the file browser to locate the file you just saved, which will be named either **face.html** or **face.htm;** select that file and click **Open** or **OK.**

Project 12

Web Page Menu

CONCEPTS COVERED

❑ Layer-based slices
❑ Slice links
❑ Rollover styles
❑ Image mapping

REQUIREMENTS

❑ A Web browser (for testing)

RESULT

❑ A graphic Web page with links to other Web pages

PROCEDURES

1. Your first word
2. Align your words
3. Style your words
4. Style a rollover
5. Create rollovers and links
6. Draw
7. Link your shirt
8. Link your head
9. Link your pants
10. Save and test

PROCEDURE 1: YOUR FIRST WORD

1. Start the ImageReady program (as discussed in Project 9, Procedure 5).

2. Create a new image named **menu, 350** pixels high, **250** pixels wide, with a **White** first layer, using the methods shown in Project 11, Procedure 1.

3. Choose the **Type** tool (shortcut: **t**) from the toolbox, and on the option bar set the **Font** to **Impact,** the **Font size** to **12 px,** the **Anti-aliasing method** to **Smooth,** and choose **Left align text.**

4. As you did in Project 9, Procedure 4, set the text's **Horizontal Scale** to **200%.**

5. Click in the upper-left corner of the image (not right in the corner, but just a little down and inside). A blinking cursor appears there.

 Clicking with the type tool (rather than dragging a text box, which you did in earlier projects) is actually the better way to set up very short bits of text.

6. Type the word **TV.**

7. Click *twice* about half an inch below where you clicked the first text into place.

 The first click says that you're done creating the previous text layer. The second click starts a new text layer.

8. Type the word **MOVIES.** Repeat step 6 and then type **MUSIC** and again for the word **COMICS.** You now have four words, stacked vertically, each on a different text layer.

. .

A DEEPER UNDERSTANDING: POINT VERSUS PARAGRAPH

When you drag the type tool to create a text bounding box, the text you enter is considered *paragraph type.* As you type, the text wraps when you hit the edge of the bounding box, and if you keep typing after hitting the bottom of the box, the text there is not visible. When you click the type tool and then type, you're creating *point type,* which does not automatically wrap (press **Return** or **Enter** for a new line). The lower limit for point type is the bottom of your image.

PROCEDURE 2: ALIGN YOUR WORDS

1. Link the four type layers together, as demonstrated in Project 6, Procedure 4.

2. From the **Layer** menu, choose **Align Linked, Left Edges.** Your text is now lined up evenly.

3. From the **Layer** menu, choose **Distribute Linked, Top Edges.** The lines of text are now evenly spaced.

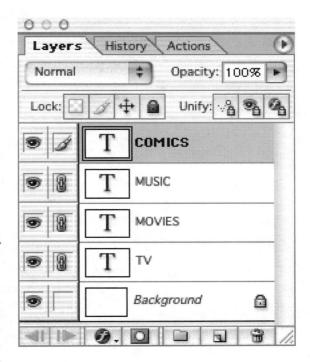

A DEEPER UNDERSTANDING: DISTRIBUTING TYPE

Type can be tricky to distribute or align vertically. Generally, you want the *baseline*, the invisible line that the type rests on, to be aligned or spaced evenly. There is no baseline option in the align and distribute commands, however.

In this project, it's easy, to align or distribute type because all of the words are in all-capitals, so all of the letters (and thus all the type bits) are the same height. You could align or distribute on the top edge, bottom edge, or vertical center, and it would come out the same. Things get trickier when you use lowercase letters. If every type layer has at least one capital, you can align the top edge, with no problem. If that's not the case, then you may have problems. Look at the words *up* and *down*. If you align them along the top edge, the word *down* would have to be lowered so that the top of the *d* is even with the top of the *u* and *p*, and then the baseline would be too low. If you line them up along the bottom edge, then the baseline of *down* is lined up with the dangling end of the *p*.

When faced with a situation like this, just add the capital letter **T** to the start of all your type layers. Align or distribute the layers based on the top edge, then delete the **T**s.

RESULT

PROCEDURE 3: STYLE YOUR WORDS

1. Select the type layer with the word **TV** by clicking on its entry on the layers palette.

 Although you can select a layer by using the **Move** tool with the **Auto Select Layer** option turned on, it's best not to. You may accidentally move your carefully aligned text.

2. From the **Layer** menu, choose **New Layer Based Slice.** ImageReady slices the image, putting the word *TV* into its own slice.

 If all of the slice lines and the slice numbers in the corners make it hard to view the contents of the slice, click the **Toggle Slices Visibility** button (shortcut: **q**).

3. From the **Layer** menu, choose **Layer Style, Color Overlay.**

You could have picked the color you wanted before setting the type. You are going to create a stored style based on what you do to this text, however. By setting a color via this command, that color will be part of the style you store, and it will become the color of anything you apply the finished style to.

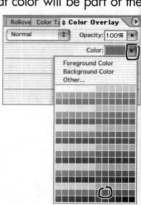

4. On the color overlay palette, click the **Color** drop menu and select a solid blue from the list that appears. The text turns blue.

 If you don't see this palette, go to the **Window** menu and choose **Layer Options/Style.**

5. From the **Layer** menu, choose **Layer Style, Bevel and Emboss.**

6. On the bevel and emboss palette, set the drop menus to **Inner Bevel** and **Smooth,** click the **Up** option, and set **Size** to **3.** Your text should now look like it's raised, with light hitting it along one edge.

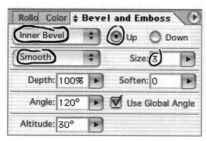

THE SCREEN

TOOLBOX

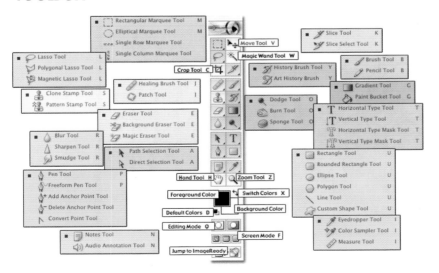

PROJECT RESULTS

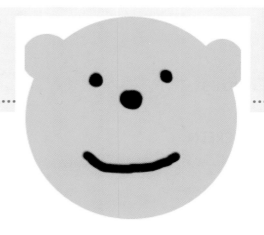

PROJECT 1: A TEDDY BEAR

PROJECT 2: COLOR IN A CARTOON

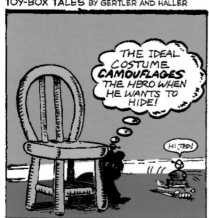

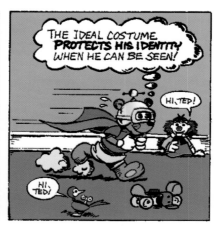

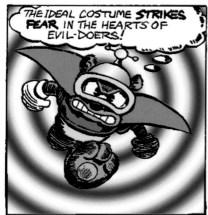

PROJECT 3: BASEBALL CARD

PROJECT 4: MAKE YOURSELF A MARTIAN

PROJECT 5: MAKE YOURSELF A MARTIAN ARMY

PROJECT 6: A SINGLE-IMAGE COLLAGE

PROJECT 7: DANGEROUS METAL PIPE

PROJECT 8: DOTTY IMAGES

PROJECT 9: ANIMATED ADVERTISEMENT

An apple a day keeps the doctor away

An apple a day keeps the doctor away

An apple a day keeps the doctor away

An apple a day keeps the doctor away

An apple a day keeps the doctor away

An apple a day keeps the doctor away

An apple a day keeps the doctor away

An apple a day keeps the doctor away
only if the doc fails to duck.

An apple a day keeps the doctor away
only if the doc fails to duck.

BANANAS

BANANAS
Fruit

BANANAS
Fruit with

BANANAS
Fruit with appeal

BANANAS
Fruit with appeal

BANANAS
Fruit with appeal

PROJECT 10: A CLOUDY DESIGN

PROJECT 11: SPOOKY EYES

**PROJECT 12: WEB
PAGE MENU**

PROJECT 13: CD TRAY CARD

N B G

MY PARENTS ARE SPECIAL

1
The Song that Never Starts

2
Just Three Words

3
Lies of the Prairie

4
Zorn's Dilemma

5
Theme from "Let's Eat!"

6
A Bridge Too Short (abridged)

7
Don Quikong

N B G

MY PARENTS ARE SPECIAL

PROJECT 14: CD INSERT

MY PARENTS ARE SPECIAL

SHAMELESS SHANE and her Troubled Troubadors

PROJECT 15: YOUR OWN LETTERHEAD

PROJECT 16: ADVERTISING POSTCARD

PROJECT 17: MATCHED MINI MASTERPIECES

PROJECT 18: WEB BACKGROUND AND LOGO

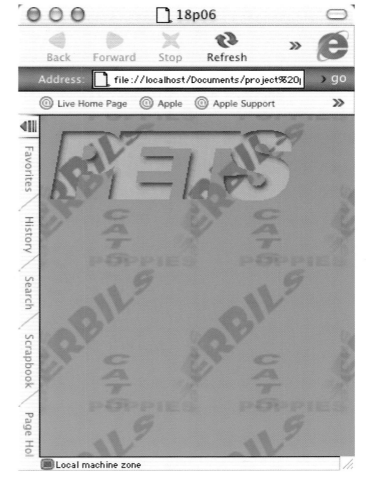

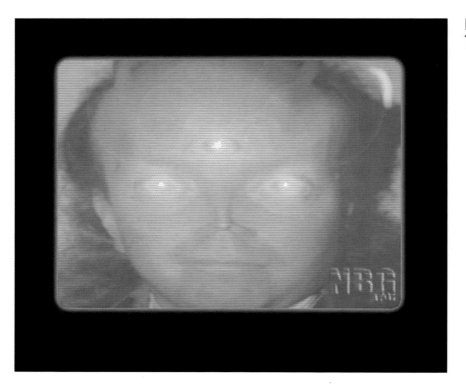

PROJECT 20: YOUR DIPLOMA

This certifies that all twenty projects in the book Project: Photoshop 7 have been properly completed by

Nat Gertler

who shall be accorded all appropriate rights, privileges, and peanut butter sandwiches.

Color mixing

RGB COLOR

When you specify colors using the RGB system, you're specifying how much red (R), green (G), and blue (B) mix together to make the color. The amount of each component color is measured from 0 (no color) to 255 (full-strength color). This diagram shows how the colors mix together at full strength. The more color you add, the brighter the result.

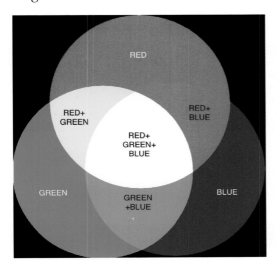

CMYK COLOR

The CMYK color specification system uses four component colors, cyan (C), magenta (M), yellow (Y), and black (K), with the amount of each component measured from 0 (no color) to 100 (full strength). This diagram shows how the colors mix together at full strength. The more color you add, the darker the result.

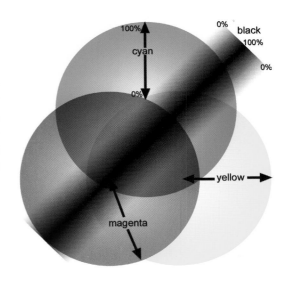

WEB COLORS

In Web design, colors are handled in RGB. The code for a color looks like #**F143BB,** which is made up of hexadecimal pairs (two-digit codes using 0–9 and A–F as digits). The **F1** is the amount of red in this color, **43** is the amount of green, and **BB** is the amount of blue.

Web browser manufacturers have standardized on a set of 216 colors that can be displayed even on systems with limited color capabilities. Each component color is limited to one of six values: **00** (decimal 0), **33** (decimal 51), **66** (decimal 102), **99** (decimal 153), **CC** (decimal 204), and **FF** (decimal 255). This chart shows all the color combinations.

Drop Shadow

Inner Shadow

Outer Glow

Inner Glow

Bevel and Emboss

Satin

Color Overlay

Gradient Overlay

Pattern Overlay

Stroke

BLEND MODES

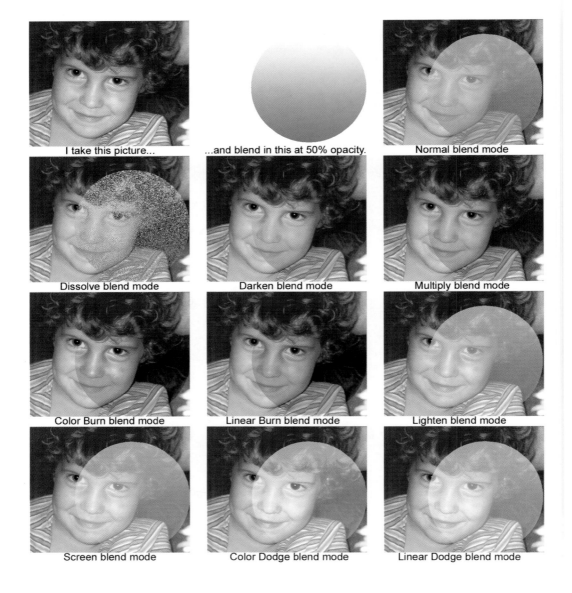

I take this picture... | ...and blend in this at 50% opacity. | Normal blend mode

Dissolve blend mode | Darken blend mode | Multiply blend mode

Color Burn blend mode | Linear Burn blend mode | Lighten blend mode

Screen blend mode | Color Dodge blend mode | Linear Dodge blend mode

BLEND MODES

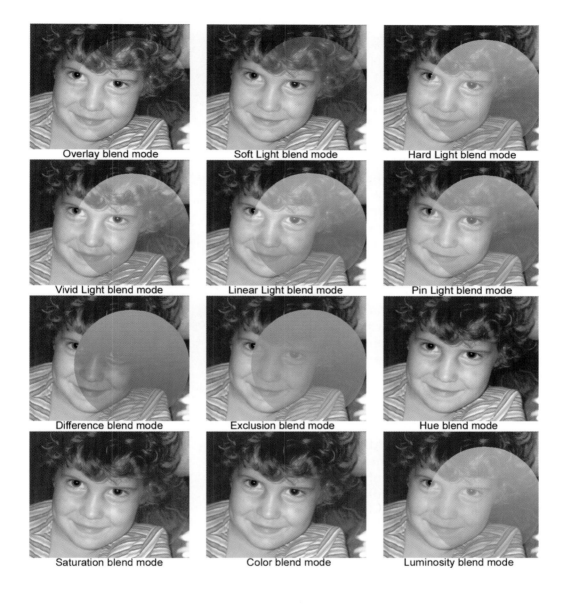

Overlay blend mode

Soft Light blend mode

Hard Light blend mode

Vivid Light blend mode

Linear Light blend mode

Pin Light blend mode

Difference blend mode

Exclusion blend mode

Hue blend mode

Saturation blend mode

Color blend mode

Luminosity blend mode

Using the color Picker

The color picker dialog box gives you an easy way of finding the right color by letting you choose the most important component of the color, set the right value for that component, then select the right color from all of the possible colors containing that component. For example, if you click the **R** option button (making the red component the most important one), you can set the red value using the slider in the middle of the dialog box. When you do that, the box at the left of the image shows you all the possible combinations of blue and green values mixed with the red value you picked. Click a spot in the box to select that color.

Similarly, if you clicked the **G** option button, the slider sets the amount of green, and the box shows all possible combinations of red and blue. Click the **B** option button, and the slider sets the blue while the box shows the combinations of red and green with that blue amount.

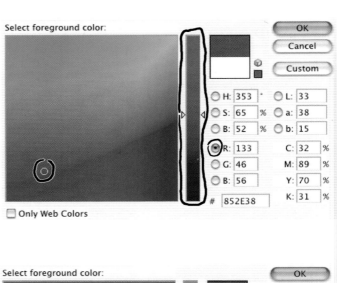

PROCEDURE 4: STYLE A ROLLOVER

1. Go to the rollovers palette and create an over state for this slice, as explained in Project 11, Procedure 4.

2. From the **Layer** menu, choose **Layer Style, Outer Glow.**

 This will make the word appear to glow when the pointer points to it. You may not be able to see the glow now against the white background, but you'll add a background later that will make it visible.

3. Create a **down** state for this slice, as explained in Project 11, Procedure 4.

4. On the layers palette, find the list of effects associated with this layer, and click on **Bevel and Emboss** to bring up the bevel and emboss palette.

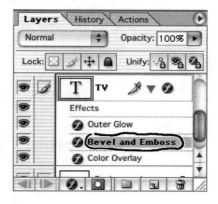

 If you don't see the list of effects, click the arrowhead next to the **f** symbol on the TV layers palette entry and the list should appear below it.

5. Click the **Down** option on the bevel and emboss palette, to make the type look pressed in when someone presses the mouse button down on it.

6. Click the arrow button on the upper right of the styles palette and choose **New Style** from the menu that appears.

7. In the dialog box, type **Shiny blue** as a name, making sure that all three options are checked, then press **OK.**

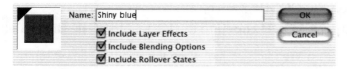

 This stores a *rollover style,* which includes not only the look of the layer in its normal state, but also the list of rollover states it has and the effects of those states.

PROCEDURE 5: CREATE ROLLOVERS AND LINKS

1. On the layers palette, select the **MOVIES** layer.

2. On the styles palette, click on the **Shiny blue** entry. Seeing that you want to create a rollover, ImageReady makes a layer-based slice of this layer and applies the styles and rollover states to this.

 On the style palette, the black triangle in the upper-left corner of the styles thumbnail means that this is a rollover style rather than a normal style. If you don't see the thumbnails on the palette, click the arrow button in the upper-right corner and choose **Small thumbnails** from the list that appears.

3. Repeat steps 1 and 2 for the **MUSIC** and **COMICS** layers.

4. From the **Window** menu, choose **Slice** to reveal the slice palette.

 Depending on your system, you may be able to reveal this by clicking the **Slice** tab on the same window as the **Rollover** palette.

5. Choose the **Slice Select** tool (shortcut: **k**) from the toolbox and click it on the **COMICS** slice.

6. Type **http://AAUGH.com** into the **URL** field of the slice palette.

 This builds a Web link, so that when this image is viewed on a Web browser, clicking **comics** will take the user to the site *AAUGH.com*. (The *http://* part lets the browser know what sort of a Web address it is.)

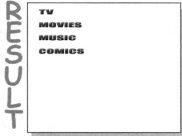

7. Repeat steps 5 and 6, building a link to **http://mp3.com** on the **MUSIC** slice, a link to **http://www.imdb.com** on the **MOVIES** slice, and a link to **http://www.tvguide.com** on the **TV** slice.

PROCEDURE 6: DRAW

1. Select the **Background** layer on the layers palette.

2. Use the **Rectangle** tool (shortcut: **u**) to draw a black rectangle behind the column of words.

 Make sure that the **Create filled region** option is selected on the option bar. Otherwise, drawing a rectangle will create a new shape layer.

3. Draw a person in the remaining open space. Don't worry about making the drawing a masterpiece. Just have some fun with the drawing tools and give us someone with a nice round head and a torso and legs beneath.

 The pencil, paintbrush, and airbrush all share the same button location in ImageReady. If you want to have quicker access to them, press down on that button and go to the very bottom of the menu that appears. There you'll see a little down arrow. Click on it and a new palette appears with just those three buttons, so any of those tools is just a click away. (That trick actually works with any toolbox button location that is used for multiple tools.)

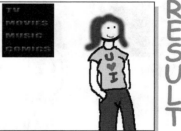

PROCEDURE 7: LINK YOUR SHIRT

1. Select the **Rectangle Image Map** tool (shortcut: **p**) from the toolbox.
2. Drag a rectangle that covers the shirt of your person.
3. Bring up the image map palette, either by going to the **Window** menu and choosing **Image Map** or by clicking the **Image Map** tab in the same window that has the rollover and slice palettes.
4. Enter the URL of your favorite Web site into the **URL** field.

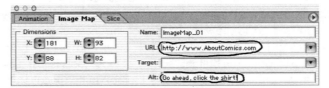

5. In the **Alt** field, type **Go ahead, click the shirt!**

 Some Web browsers will display this text whenever the pointer is on the shirt.

· ·

A DEEPER UNDERSTANDING: SLICES VERSUS IMAGE MAPS

Both *slices* and *image maps* can be used to turn areas of your image into Web links but they work in different ways.

Slicing an image creates a separate Web graphic file for each slice. Because Web graphic files are rectangular (although they may have transparent edges), these slices are always rectangular. You can also connect a rollover to the slice area.

An image map doesn't make a separate graphics file for the linked area. Instead, it just keeps track of what areas of your image are linked. The mapped area can be square, circular, or it can be any flat-sided shape. And you cannot create a rollover for an image mapped area.

PROCEDURE 8: LINK YOUR HEAD

1. Select the **Circle Image Map** tool (shortcut: **p**) from the toolbox.

2. Drag a square that covers your entire head. A circle with a bounding box and selection handles appears.

3. Select the **Image Map Select** tool (shortcut: **p**) from the toolbox.

 It shares the same button space with the other image map tools.

4. Adjust the sizing handles so that the circle covers your head as closely as possible. Remember, this is a circle, not an ellipse, so you may not be able to fit it as close on all sides as you might want.

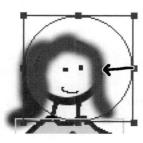

 It's better to cover a little too much, and thus make some extra space clickable, than to cover too little.

5. On the Image Map palette, enter **face.html** into the **URL** field and **Spooky eyes** into the **Alt** field.

 You'll be saving this file in the same directory where you saved the results of Project 11. By listing the file name of that project as the link address, clicking on the head here will bring up that face. (You don't need the *http://* when the file you're linking from is on the same computer as the one you're linking to.)

PROCEDURE 9: LINK YOUR PANTS

1. Select the **Polygon Image Map** tool (shortcut: **p**) from the toolbox.

2. Click a series of points around the edges of your person's pants. This is similar to using the polygon lasso tool (as you did in Project 2, Procedure 7), but you don't have to worry about being so precise. Being off by a pixel here or there will not make much difference.

3. When you've clicked your last point, double-click. The area you clicked around will now be highlighted.

4. On the Image Map palette, enter **mailto:,** followed by your e-mail address in the **URL** field.

 When someone clicks a *mailto* link, the email program starts up with an email addressed to the indicated address.

A DEEPER UNDERSTANDING: TARGET

The *Target* field on the image map palette can be used to load the linked image into a specific part of the browser screen (using a feature called *frames*) or to launch a new browser window for the image. If you read about frames in any good book on HTML, then you will see how to use this field. If you don't know about frames, just leave this field alone.

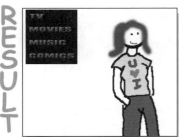

PROCEDURE 10: SAVE AND TEST

1. Save the file both as a Photoshop file and as a set of Web files, using the same method you used with the last project. Save the Web files in the same directory as you did in Project 11.

2. Start up your Web browser and open **menu.html** (or **menu.htm**, whichever you find) from the directory you saved it in.

3. Move your pointer over the rollovers to see them at work. Test the various links you added. When you get carried to another Web page, click the browser's **Back** button to return to the page you made.

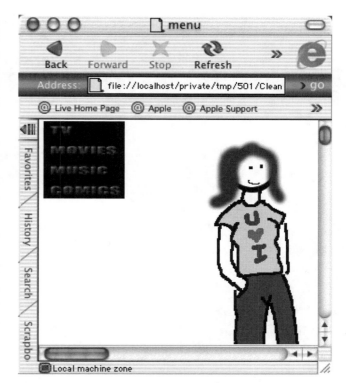

RESULT

Project 13
CD Tray Card

CONCEPTS COVERED

- ❏ Working in CMYK mode
- ❏ Rulers
- ❏ Guides
- ❏ Channels

REQUIREMENTS

- ❏ A printer (if you actually want to print it out, although of course you don't have to)

RESULT

- ❏ A design for the card that goes in the back of a CD case

PROCEDURES

1. Start a CMYK image
2. Put up guides
3. Fashion a background
4. Add a track listing
5. Make text clear
6. Purify your black
7. Name the album
8. Create logo space
9. Add your logo
10. Print it out

PROCEDURE 1: START A **CMYK** IMAGE

1. In Photoshop, from the **File** menu, choose **New**.

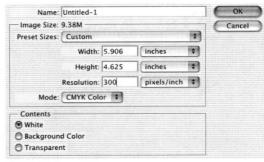

2. Set **Width** to **5.906 inches** and **Height** to **4.625 inches**.

These are the dimensions of a standard CD tray, 5 29/32 inches by 4 5/8 inches, rounded to the nearest thousandth of an inch.

3. Set **Resolution** to **300 pixels/inch**.

If you're working on a particularly slow system or one with little memory, set the resolution to **72 pixels/inch.** The printed result won't look as good, but the learning experience will work out fine.

4. Set **Mode** to **CMYK Color** then click **OK**.

A DEEPER UNDERSTANDING: CMYK MODE

In the previous projects you've worked in *RGB mode*, where Photoshop keeps track of each color based on how much red, green, and blue are mixed together to create that color on the screen. The more of each color you add, the brighter the screen pixel gets. The amount of each color is measured on a scale from 0 to 255, because those numbers are easy for computers to deal with.

Printing technology works differently. Most full-color printing systems use a four-color system. Each printed color is a mixture of *cyan* (a shade of blue, abbreviated C), *magenta* (a shade of red, abbreviated M), *yellow* (abbreviated Y), and *black* (abbreviated K, because B is used for Blue). Because paper is white, if you don't add color, it will be as bright as possible. The more ink you add, the darker a color you will get. The amount of each color you can add is measured on a percent scale from 0 to 100, a standard set by humans running print shops.

PROCEDURE 2: PUT UP GUIDES

1. From the **View** menu, choose **Rulers.** Rulers appear along the upper and left edges of the image, measuring the distance from the upper-left corner.

 If you already have ruler lines on the image, skip this step.

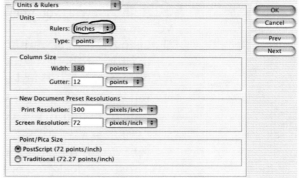

2. *Double-click* (press the mouse button twice quickly) on the ruler. A dialog box appears.

3. In the **Units** area, set the **Rulers** measurement to **inches** then click **OK.**

4. From the **View** menu, choose **New Guide.** A dialog box appears.

5. Set **Orientation** to **Vertical, Position** to **.25 in,** then click **OK.**
A vertical line appears to the left of your image.

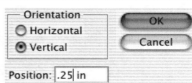

 CD tray cards include not just the back of the CD case, but also the material on the edges. This guide marks where the quarter-inch-wide edge ends and the back begins.

6. Repeat steps 4 and 5 to set another guide at **5.656 in** (that's a quarter inch from the right edge of the image, showing where the other edge of the card ends) and another one at **2.953 in** (that guide is in the middle of the image, where you'll use it to line up some text).

 If you don't see these guide lines, go to the **View** menu and choose **Show, Guides.**

7. On the **View** menu, make sure there are checks next to **Lock Guides** (which prevents you from accidentally dragging a guide out of place) and **Snap.** If not, choose them.

8. Again on the **View** menu, in the **Snap To** submenu, make sure there are checks next to **Guides** and **Document Bounds.** If not, choose them.

PROCEDURE 3: FASHION A BACKGROUND

1. Click the arrow button in the upper right of the color palette, and choose **CMYK Sliders** from the menu that appears. The color palette now has four sliders for mixing percentages of C, M, Y, and K.

2. Click the arrow button again and choose **CMYK Spectrum.**

 This prevents you from choosing unprintable colors.

3. Using the **Rectangular Marquee** tool (shortcut: **m**) drag from the top of the left guide to the bottom of the right guide. The back area of the card is now selected.

4. Fill the selected area with a radial gradient fading from bright blue to deep purple, centered in the middle of the picture. (See Project 2, Procedures 6 and 8 if you forget how to do this.)

5. Pull down the **Filter** menu. (A lot of the filters are grayed out. Those are designed only to work in RGB and grayscale modes.) Choose **Stylize, Extrude.** A dialog box appears.

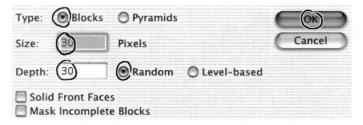

6. Set **Type** to **Blocks, Size** to **30** pixels (unless you set up your image for 72 pixels per inch, in which case use 7 pixels), and **Depth** to **30 Random.** Clear both check boxes and click **OK.**

 Don't panic if this effect takes a minute or two on a slow machine. It looks cool when it is complete, as if the image is made up of 3-D blocks.

7. From the **Select** menu, choose **Deselect.**

PROCEDURE 4: ADD A TRACK LISTING

1. Set the foreground color to black.

2. Choose the **Horizontal Type** tool (shortcut: **t**) from the toolbox and reset the tool.

3. Set the **Font** to **Verdana,** the **Font size** to **12 pt,** and click **Center text** on the option bar.

4. Click on the center guide toward the top but not touching the top.

5. Type 1 (for the CD track number) and then press **Enter** or **Return.**

> Don't worry if the guide line hides the number. Guide lines don't show up on the printed product. They're just there to help you while you compose the image.

6. Type the name of a song (feel free to make one up), then press **Enter** or **Return** *twice,* to skip a line between songs.

7. Repeat steps 5 and 6 for tracks 2, 3, and so on, until you're close to the bottom of the image.

8. Click the check mark on the option bar to indicate you're done editing text. (Don't worry that the text is hard to read against this background. You're about to fix that.)

PROCEDURE 5: MAKE TEXT CLEAR

1. On the layers palette, select the **Background** layer.

2. Open the channels palette by clicking the **Channels** tab or by going to the **Window** menu and choosing **Channels.**

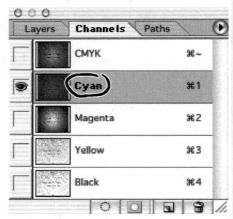

3. Click the **Cyan** entry on the palette. The image display changes to grayscale, with the level of gray indicating how much cyan is in that pixel. Your gradient ran from blue to purple, both of which are made with a lot of cyan, so the image is now dark.

4. Set your foreground color to **White.**

5. Choose the **Rectangle** tool (shortcut: **u**) from the toolbox, and click the **Fill pixels** option on the option bar.

6. Drag a rectangle that encloses all of the song names.

7. Click the **CMYK** entry on the channels palette. The color is now much lighter and red and the text is more visible where you placed the rectangle.

A DEEPER UNDERSTANDING: CHANNELS

Whether working in RGB mode or CMYK mode, Photoshop doesn't think of a layer as being in full color. Instead, it thinks of the layer as having several channels (in this case, a C, an M, a Y, and a K channel), each of which is a grayscale image representing how much of each color is in each pixel. These channels are constantly combined to display the image.

Normally, anything you do to a layer changes all channels. By selecting the Cyan channel, you told Photoshop that your command should change the amount of cyan while leaving the other channels alone. Painting white on that layer set the level of cyan in that area to zero, but it had no effect on the magenta level of each pixel, which we still see behind the words.

PROCEDURE 6: PURIFY YOUR BLACK

1. Set your foreground color to black.

2. On the color palette, you will see that the black you selected isn't made up of only black ink. Instead, it mixes a lot of cyan, magenta, and yellow with the black. Adjust the sliders so that the **C, M,** and **Y** values are 0%, and the **K** value is 100%.

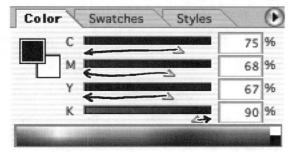

 Photoshop mixes other colors in with the black to make a *rich black*, which will show up as a good solid black against other colors.

3. Open the swatches palette, click the arrow button in the upper-right corner, and choose **New Swatch.**

 You're saving the color you just made so that you can quickly get it back later by clicking its entry on the end of the swatches palette.

4. In the dialog box that appears, enter the name **Pure Black,** then click **OK** to store the color with that name.

 Although a rich black is good when it's surrounded by color, it can cause problems when you're printing black on a white background. If the printing presses don't line up the four colors exactly, you'll see color fringing around edges of your black. By making the black *pure black,* you eliminate the other colors so there's no risk of that happening.

PROCEDURE 7: NAME THE ALBUM

1. Choose the **Horizontal Type** tool (shortcut: **t**) from the toolbox. (The existing settings should be fine.)

2. Drag a text box into place on your image.

 It doesn't matter where this text box is, because you're going to move it, but avoid starting the text box in the existing highlighted text area, or Photoshop might think you're trying to select that text.

3. Type a short title for the album, with no more than four words.

4. Point to a spot to the right of the text box, and the pointer turns into a curved line with two arrowheads.

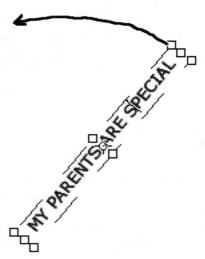

5. Drag up and to the left, and the text rotates. Rotate it a full 90 degrees counterclockwise.

 Hold down **Shift** while you drag. This makes the rotation take place in 15-degree jumps, making it easy to get exactly 90 degrees.

6. Click the check mark on the option bar to show you're done editing text.

7. Use the **Move** tool (shortcut: **v**) to drag the title onto the left edge area of the image, putting it low in the edge column. Then, while holding down the Windows **Alt** key or Macintosh **Option** key, drag a copy of the title to the right edge area.

 The text may jump around a lot as you drag it to the edge. This is because you have snap turned on, so Photoshop keeps trying to line the text box up with the guide or the edge of the box. This makes it easy to place the text where you want it.

PROCEDURE 8: CREATE LOGO SPACE

1. On the layers palette, select the **Background** layer.

2. On the channels palette, select the **Magenta** channel. You now see it in grayscale.

3. Select the standard black color, as opposed to the pure black colore you probably have selected.

 You're drawing on the magenta channel. Pure black doesn't include any magenta, and won't show up on the magenta channel.

4. Use the **Rectangle** tool (shortcut: **u**) to drag rectangles covering the top inch of both edges.

 As you move your pointer, little dotted lines move along the rulers, showing the position of your pointer. Watching these lines should make it easier to find the 1-inch mark while drawing on the right margin.

5. On the channels palette, click the **CMYK** channel. The image turns to color again.

PROCEDURE 9: ADD YOUR LOGO

1. Using the color palette, set the foreground to **60% Y, 0% C, M,** and **K.**

2. Choose the **Vertical Type** tool (shortcut: **t**) from the toolbox.

3. On the option bar, set the **Font** to **Impact,** the **Font Size** to **18,** and **Anti-alias** to **None.**

4. Click in the middle of the magenta stripe on the left edge, type your initials, then click the check mark on the end of the option bar.

5. Repeat step 4 on the right edge.

 If you want to keep a copy of your image with all your layers, save it now!

6. From the **Image** menu, choose **Trap.**

 Trapping spreads color around wherever two colors touch. This way, if the printing presses for different colors aren't lined up precisely, you're still okay. Otherwise, there would be a visible white gap at the edges where the color didn't line up.

7. A dialog box asks you if you want to flatten your layers. Click **OK,** and all your layers are reduced to a single raster version of your image.

8. In the dialog box that appears, set the width to **2 pixels.**

 When you're actually preparing material for a commercial printer, the printer will tell you what value to set. (It varies depending on the precision of their equipment.)

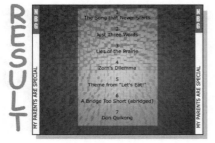

PROCEDURE 10: PRINT IT OUT

1. Save the file.
2. From the **File** menu, choose **Print with Preview** A dialog box appears.

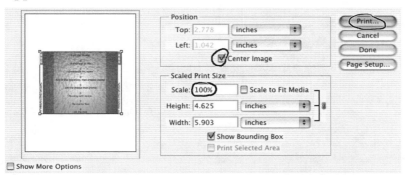

☐ Show More Options

 Photoshop's printing commands can vary depending on what type of printer you have configured, so your dialog box may not look quite like what you see here. Even the name of the command can vary, but you should be able to identify it if you look at your file menu.

3. Make certain the **Center Image** option is selected and the **Scale** is **100%**.
4. Click **Print.** Another dialog box appears.
5. Click **Print.** The image is sent to your computer's printer.

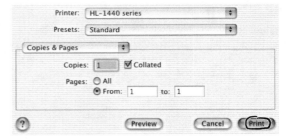

A DEEPER UNDERSTANDING: COMMERCIAL PRINTING

The only "deeper understanding" about commercial printing that I can convey here is that there is nowhere near enough space here to give you a proper understanding. *Prepress,* the craft of preparing material for commercial printing, is a deep topic. There are a number of big, thick books on preparing material for printing. Don't make the mistake of believing that whatever Photoshop file you create is ready to go to press.

PROJECT 14
CD INSERT

CONCEPTS COVERED

- ❏ Gamut warnings
- ❏ Noise filter
- ❏ Quick Mask mode
- ❏ Making and using alpha channels
- ❏ Lighting effects
- ❏ Adjustment layers
- ❏ Text selection

REQUIREMENTS

- ❏ None

RESULT

- ❏ A CD front cover design

PROCEDURES

1. Pick your sand color
2. Make sand
3. Write your title
4. Make an alpha channel
5. Light up your image
6. Press your title in the sand
7. Darken the deep sand
8. Select a band name
9. Convert to CMYK

PROCEDURE 1: PICK YOUR SAND COLOR

1. In Photoshop, click the arrow button on the upper right of the color palette. Choose **RGB Sliders.**

 Don't worry; you're not supposed to have an image open yet.

2. You want to set the background color to the color of sand, so click the **background color box** on the color palette, then set **R** to **255, G** to **165,** and **B** to **0.**

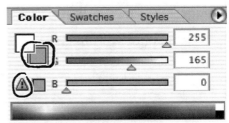

3. On the color palette, a symbol appears with an exclamation point in a triangle. Click this symbol. The color changes slightly.

 This symbol warns you that you've selected an unprintable color. Clicking on it adjusts the color to the most similar printable color.

4. Open a new file with both **Width** and **Height** set to **4.75 inches, Resolution** at **300 pixels/inch** (pick a lower figure if you have a slow computer), **Mode** set to **RGB Color,** and **Contents** set to **Background color.**

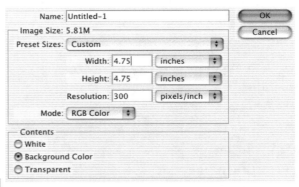

 You are designing something to be printed so you want to end up with a CMYK image, but you will be using filters that don't work in CMYK mode. Start with an RGB image and convert it to CMYK later.

PROCEDURE 2: MAKE SAND

1. From the Filter menu choose **Noise, Add Noise.** A dialog box appears.

 Sand is not a solid color. By adding *noise* (dots of varying color), you give your image the visual texture of sand. Correct texture is often more important than correct color.

2. Set **Amount to 20**% and **Distribution** to **Gaussian.**

 Gaussian gives you a rougher-looking sand than *Uniform* does. Working at 300 dots per inch, if you make your details too fine, those details won't be visible.

3. Put a check mark in the **Monochromatic** check box.

 This keeps your sand in the brown range, rather than introducing dots of red and green into it.

4. Click **OK** and your sand appears.

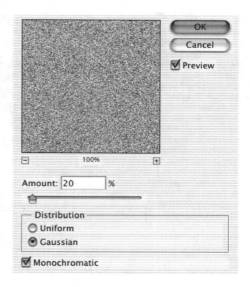

RESULT

PROCEDURE 3: WRITE YOUR TITLE

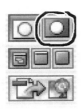

1. Click on the **Edit in Quick Mask Mode** button (shortcut: **q**) in the toolbox.

 This mode lets you *paint* a selection area using the standard paint tools.

2. Choose the **Brush** tool with airbrush capabilities, as you did in Project 10, Procedure 6.

3. Set the foreground color to black.

 When you paint in quick mask mode, you're limited to grayscale colors. This is because you're not actually putting color on the drawing. What you're painting is the selection areas. Areas that you paint black are selected. Areas that are left white are unselected. Areas that are gray are partially selected.

4. On the option bar, set the **Brush** to a **Soft round 65 pixels** brush, with **Flow** set to **75%**.

 To see the brush names, click the **Brush** drop list on the option bar, then click the arrow button on the list and choose **Large List** from the menu.

5. Write the name of your album using your mouse to give it a handwritten look rather than a set font. As you write, the name appears as a color tinting of the sand.

 To change the color of the tint, double-click the **Edit in Quick Mask Mode** button. This may be needed if the main color of your image is the same as the color of the tint.

R
E
S
U
L
T

A DEEPER UNDERSTANDING: QUICK MASK MODE

You can create a selection using normal selection tools then entering quick mask mode to edit the borders of the selection area.

PROCEDURE 4: MAKE AN ALPHA CHANNEL

1. Click the **Edit in Standard Mode** button (shortcut: **q**) in the toolbox. A marquee runs around the words you wrote and also around the outside edge of the image. Everything between those marquees—in other words, all of the image except where you wrote—is now selected.

2. Open the channels palette by going to the **Window** menu and choosing **Channels,** or by clicking the **Channels** tab on the layers palette.

3. Click the **Save selection as channel** button on the channels palette. A new channel named Alpha 1 appears on the list. The thumbnail for this channel has a picture of what you wrote.

4. From the **Select** menu, choose **Deselect** to clear the selection.

A DEEPER UNDERSTANDING: ALPHA CHANNELS

There are a number of grayscale images that Photoshop uses in making up your whole image. For example, a layer mask is a grayscale image. On each layer, each of the color channels (red, green, and blue, or cyan, magenta, yellow, and black) is a grayscale image, with the level of gray for each pixel indicating how much of that color is in the main image.

An *alpha channel* is another grayscale image. What does it do to your image? Nothing! That's the whole point. An alpha channel is like a cubbyhole, where you can store a grayscale image that you may want to use later. As long as the image stays in that cubbyhole, it doesn't alter the appearance of your image.

RESULT

PROCEDURE 5: LIGHT UP YOUR IMAGE

1. From the **Filter** menu, choose **Render, Lighting Effects.** A dialog box appears.

2. From the **Style** list, choose **2 o'clock Spotlight.** In the preview area of the image, you'll see what looks like the light of a flashlight being pointed at dark sand. An oval with the white dot at the center

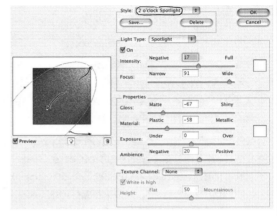

indicates the positioning of the light.

3. Drag the white dot so that it's midway between the center and the lower-left corner of your image preview.

 This dot indicates where the light shines *at.*

4. There's a line running from the center white dot to one of the four sizing handles on the oval. Drag that sizing handle to the upper-right corner of the image preview.

 This dot indicates where the light shines *from.*

5. There are two sizing handles at the sides of the oval. Drag either one of these away from the center white dot. As you do, the oval gets wider. Keep dragging until the oval is so big that the entire preview area is inside. The entire preview is now lit, although not evenly.

R
E
S
U
L
T

A DEEPER UNDERSTANDING: LIGHTING EFFECTS

You can add more lights to the image by dragging the lightbulb icon from below the preview area onto the image. On the right are many settings about the type of light and the way it should shine on material. Try choosing different styles of light from the **Style** list to get a better sense of the full range of this filter's power.

PROCEDURE 6: PRESS YOUR TITLE IN THE SAND

1. From the **Texture Channel** drop list, choose **Alpha 1.** The words you stored in the alpha channel now appear in the preview.

 A *texture* is a variation in height. Photoshop treats the alpha channel as an indicator of how high each pixel is. These height differences are used in the lighting effect to decide where the highlights and shadows fall.

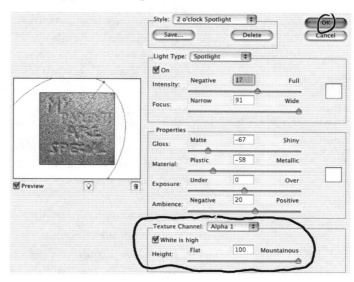

2. Put a check in the **White is high** check box.

 You want the words that you painted on the alpha channel to look sunk into the sand, as though you had written in wet sand with your finger. Because you painted the words in black, and you want them lower than the rest of the image, that means that the white parts of your image need to be the highest.

3. Set the **Height** slider to the **Mountainous** setting all the way at the right.

 Mountainous is a relative term. We want the letters you wrote to be as deep as this filter can make them, which isn't very deep.

4. Click **OK.** Your words are now carved into your image.

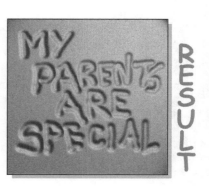

PROCEDURE 7: DARKEN THE DEEP SAND

1. On the channels palette, drag the **Alpha 1** entry onto the **Load channel as selection** button on the bottom of the channels palette. Photoshop rebuilds the selection based on that channel.

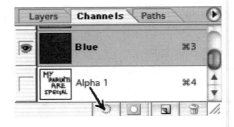

2. From the **Select** menu, choose **Inverse,** so that only the letters are selected (rather than everything but the letters).

3. From the **Select** menu, choose **Modify, Contract,** and enter **5** pixels in the dialog box that appears. Click **OK,** and the selected area contracts slightly, so that only the deepest sand is selected.

4. From the **Layer** menu, choose **New Adjustment Layer, Brightness/Contrast.**

5. On the New Layer dialog box that appears, click **OK,** and a Brightness/Contrast dialog box appears.

 Many dialog boxes have a **Preview** option, which causes the change to show up on the image before you click **OK.** This is very handy, but slower machines can slow things down a lot.

6. Set **Brightness to –25** to make the selected areas darker, as if the sand is wetter.

7. Set **Contrast to –25** to make the selected areas more even in color.

8. Click **OK.**

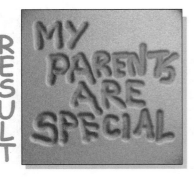

PROCEDURE 8: SELECT A BAND NAME

1. On the layers palette, select the layer **Background.**

2. Get the **Horizontal Type Mask** tool (shortcut: **t**) from the toolbox and reset the tool.

3. Click the text tool where you want the name of the band. The image becomes tinted.

 This is like the mask editing mode. The tint shows the areas that aren't selected, which is the whole image at this point.

4. Using your choice of font and font size, type in the name of your band. The tint disappears where you type, meaning that the letter shapes are selected.

If you can't think up a band name, think of the name of a favorite album, taking the two most important words from it and put them in reverse order. This way, you could come up with *California Hotel, Pepper's Sergeant, HellBat, Grammar Country,* or *Father Dogg,* all of which sound as pointless as real band names. (And if I find out that all of you are naming your band *Hits Greatest,* I'm just giving up on the future of album-oriented music.)

5. Click the check mark button on the end of the option bar to show you're done editing text. The tint disappears, and there is now a marquee around your band name.

6. From the **Image** menu, choose **Adjustments, Invert.** The selected area keeps the sandy texture, but turns a blue shade that is the opposite of the sandy color.

7. From the **Select** menu, choose **Deselect.**

PROCEDURE 9: CONVERT TO CMYK

1. From the **Image** menu, choose **Mode, CMYK Color.**

2. A dialog box appears asking if you want to flatten your image before changing the mode. Click **Don't Flatten.** Photoshop spends time recalculating the image, and some of the colors will look different now.

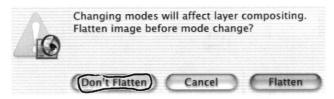

Changing modes will affect layer compositing.
Flatten image before mode change?

Don't Flatten Cancel Flatten

 If you had told Photoshop to flatten the image, it would have captured what your image looked like and matched those colors as best as possible. Instead, it took the background and matched those colors as closely as it could. The Brightness/Contrast layer, however, performs its magic based on mathematical calculations. Those mathematical calculations come out differently when applied to the CMYK colors than they did when applied to the RGB colors, making the darkened areas even darker.

3. From the **Layer** menu, choose **Flatten Image.** The current image is now flattened to a single layer.

4. On the channels palette, drag the **Alpha 1** entry onto the **Delete current channel** button.

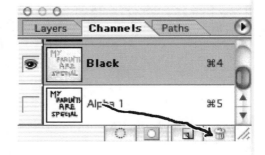

 You are done with this alpha channel, and if you save the file without deleting it, it will just take up disk space.

5. Print the file, as shown in Project 13, Procedure 10.

6. Save the file.

CONCEPTS COVERED

- ❏ Converting text to a shape
- ❏ Deleting anchor points
- ❏ Storing a custom shape
- ❏ Drawing straight lines
- ❏ File info
- ❏ Page setup

REQUIREMENTS

- ❏ A printer (if you actually want to print it out, although of course you don't have to)

RESULT

- ❏ Printed letterhead with your own custom logo

PROCEDURES

1. Sharpen up Inc
2. Make a custom shape
3. Make your logo
4. Add racing stripes
5. Save your logo
6. Put your logo on letterhead
7. Draw a straight arrow
8. Place and space your text
9. Store your file info
10. Print your letterhead

PROCEDURE 1: SHARPEN UP INC

1. Start a new image, **1 inch** wide, **.5 inch** high, **300 pixels/inch,** and with **Contents** set to **Transparent.**

2. Create a text layer and, with **Font** set to **Impact** and **Font size** set to **24 pt,** put the word **INC** on it.

 Impact is a very simple font, which makes it easy to work with. Fonts with *serifs* (little lines at the end of the stroke of each letter) or other fanciness look fine in their normal state, but can end up looking convoluted or messy if you do much work with them.

3. From the **Layer** menu, choose **Type, Convert to Shape.** The text layer becomes a path layer, with the shape of the letters being your clipping path.

4. From the toolbox, choose the **Delete Anchor Point** tool (which is used so rarely, it doesn't even have a shortcut).

 Be careful. This tool shares its button positions with similar-looking buttons. You want the one with the minus sign next to the pen point.

5. Drag a rectangle around **INC** to select it. The anchor points appear on the edges of the shape.

6. Click this tool on the upper-right corner of the letter I. The anchor point there disappears, reducing the simple rectangle to a simple triangle.

 You may need to click twice. The first time makes the anchor point visible; the second eliminates it.

7. Use this tool to remove the following points: the upper-right corner of the first vertical bar of the letter N, the lower-left corner of the second vertical bar, the right corner of the top end of the letter C's curve, and the inside corner of the bottom end.

PROCEDURE 2: MAKE A CUSTOM SHAPE

1. From the **Edit** menu, choose **Define Custom Shape.** A dialog box appears.

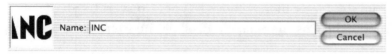

2. Type **INC** as the (far too obvious) name for your custom shape, then click **OK.**

3. On the history palette, scroll back to the very beginning of the history list and click the first entry marked **New.** That stylized INC you spent all that time creating just disappears!

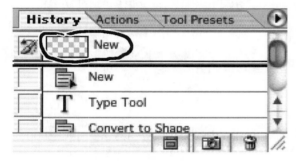

 You don't need that INC anymore. The copy you stored as a custom shape is all you need. You need another image that's the same size, so rather than closing the INC image and opening a new one, you're just resetting the image to its blank state.

R
E
S
U
L
T

PROCEDURE 3: MAKE YOUR LOGO

1. Create a type layer with your initials, using the same font and size that you used for INC.
2. From the **Layer** menu, choose **Type, Convert to Shape.**
3. Choose the **Custom Shape** tool (shortcut: **u**) from the toolbox.

 The custom shape tool doesn't always show the same image. It shows the image of the custom shape you used last.

4. On the option bar, select the **Exclude overlapping shape areas** option, then click the **Shape** drop list and choose the **INC** shape from the shapes that appear.

 The selected button in the toolbox now has the INC shape. You designed a button!

5. On the option bar, click the **Geometry options** drop arrow, then select the **Defined Proportions** option on the list that appears.

This keeps you from stretching **INC** out of proportion, although if this option hadn't been selected, you could have the same effect by holding down **Shift** while placing the shape.

6. Drag the INC shape into place so that it's as wide as your final letter. Place it so that the top third of the INC overlaps with the bottom of your last initial.

PROCEDURE 4: ADD RACING STRIPES

1. On the option bar, click the **Subtract from shape area** option and the **Rectangle** tool, then click the **Geometry options** drop arrow.

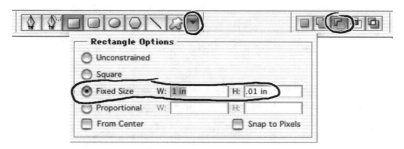

2. Select the **Fixed Size** option, setting the width (**W**) to **1** inch and the height (**H**) to **.01** inch.

3. Point to the image area and hold down your mouse button. A wide, shallow rectangle appears. Drag it into place so that it cuts across all of your initials just below the top edge of the letters.

4. Click the **Geometry options** drop arrow again and set the height (**H**) to **.015** inch.

5. Place another line, just a little below the first one.

RESULT

PROCEDURE 5: SAVE YOUR LOGO

1. Save this shape just as you did in Procedure 2, naming it after yourself.

2. On the option bar, click the **Custom shape** tool, then open the **Shape** drop list.

3. While holding down the Windows **Alt** key or Macintosh **Option** key, click on the **INC** shape. The shape disappears from the list.

 You only needed INC while we were working on the whole logo. There's no reason to keep it hanging around.

4. In the same manner, delete all of the other shapes *except* your logo.

 Those shapes are already stored on disk. You aren't deleting them from disk, you're just taking them off the list temporarily. You're creating a new shapes file for just the shapes you've created (well, *shape*, because it's only one so far) and you only want that on the list. (Although can you really consider it a list when it has only one item? That's like having one woman standing in line.)

5. Click the arrow button on the upper right of the list and choose **Save Shapes** from the menu that appears.

6. A file browser appears. Type **My shapes** as the name of your file, then click **Save**.

To reload this shape file, click the arrow button you have just used and choose **Load Shapes**.

7. Click the arrow button on the list again and choose **Reset Shapes**. On the dialog box that appears, click **Append**. You now have the default shapes on your list as well as your logo.

PROCEDURE 6: PUT YOUR LOGO ON LETTERHEAD

1. From the **File** menu, choose **Close** to get rid of the current image. When a dialog box asks you if you want to save the changes, click **Don't Save.**

 You've already saved the logo as a shape, so you don't need this file (unless you want to touch up the logo later, in which case you should save it).

2. Start a new white image, **8 inches** wide, **1.5 inches** high (we're only designing the top of the page), **300 pixels/inch.**

3. Set the foreground color to a dark red.

4. Choose the **Custom shape** tool and select your logo as the shape.

5. Click the **Geometry options** drop arrow button, and set the **Fixed Size** options with **W** set to **2** inches and **H** set to **1.**

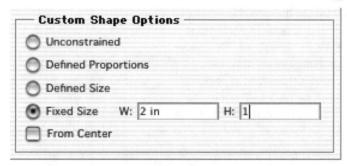

6. Place the logo at the far left of your image, vertically centered.

7. Click the little button between the shape area options and the style drop list on the option bar to indicate you're done with this layout.

RESULT

PROCEDURE 7: DRAW A STRAIGHT ARROW

1. Set the foreground color to black.

 If you're working in CMYK, use pure black, as described in Project 13, Procedure 6.

2. On the option bar, choose the **Line** tool, and set the **Weight** to 5 px.

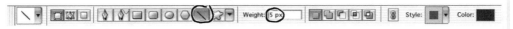

3. Click the **Geometry options** drop arrow to see options about putting arrowheads on the end of your line.

4. Select the **End** option, set the **Width** to **600%,** the **Length** to **1000%,** and the **Concavity** to **–25%.**

 The length and width percentages are relative to the line thickness (the *weight*). The concavity percentage is relative to the length of the arrowhead and measures how much the base of the arrowhead is indented. By setting a negative value here, you're saying not only not to indent the base but to actually push it out, giving the arrow a diamond shape.

5. Point at about level with the bottom of your initials and a quarter inch to the right of the end of your logo.

6. Start to drag, press down **Shift**, and drag all the way to the right edge of the picture to place your arrow.

 Holding down the shift key keeps your line precisely horizontal. If you press it down before starting your drag, however, Photoshop will think that you were adding this shape to some previous selection.

PROCEDURE 8: PLACE AND SPACE YOUR TEXT

1. Get the **Horizontal Type** tool (shortcut: **t**) from the toolbox, reset it, and set the font to **Comic Sans MS,** the font size to **8 pt,** and click the **Right align text** option.

2. Click so that the top of the pointer touches the arrow line, just to the left of the arrowhead.

3. Type your address and phone number IN ALL CAPITAL letters, then click the check mark on the option bar to show that you're done.

4. Click so that the *bottom* of the pointer touches the arrow line, just to the left of the arrowhead, then type a five- or six-word slogan for your company using upper- and lowercase.

5. Select this text by pointing to one end of it and dragging across it.

 Make sure your pointer is the text pointer (it looks like a capital I) rather than the move pointer (an arrowhead) before you start dragging. Otherwise, you will move the text.

6. Open the character palette.

7. Click the **Faux Italic** and **Small Caps** buttons.

 Many fonts include a separate *italic* (slanted) version in its font style, but Comics Sans MS is not one of them. The faux italics option slants the letters but not with the same grace that a font style would. The small caps option replaces lowercase letters with smaller capital letters.

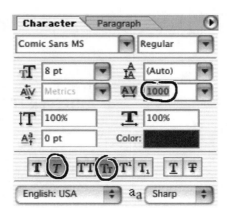

8. Adjust the **Tracking** value, which sets spacing between letters, so that the slogan is stretched as far along the arrow line as possible. You'll probably need to try values between 500 and 1000.

9. Click the check mark on the option bar.

PROCEDURE 9: STORE YOUR FILE INFO

1. From the **File** menu, choose **File Info.** A dialog box appears.

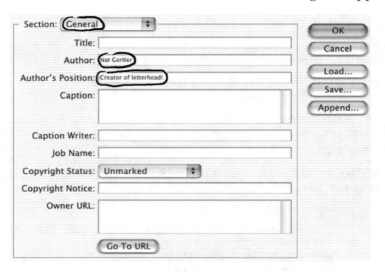

2. From the **Selection** drop list, choose **General.**

3. Type your name into the **Author** field.

4. Type **Creator of letterhead!** into the **Author's Position** field.

5. Click **OK.**

. .

A DEEPER UNDERSTANDING: FILE INFO

There's really no need for you to store any of this information in this file. I did want to show you how it's done if you ever need to do it.

Why would you need to do it? If you're producing material for something that uses a large amount of information, such as a magazine, this information can be used to locate specific files. It also stores all the relevant information about a file with the file, so if there are questions about it, it will show what the file is supposed to be and who to contact for more information. (The format of the information is actually standardized by the International Press Telecommunications Council and the Newspaper Association of America. Because it's a standard, some programs can search that information to help locate specific files.)

RESULT

NBG inc

WHOLESALE WRITING AT RETAIL PRICES

1160 N CONWELL AVE #212, COVINA CA 91722 (626) 555-0900

PROCEDURE 10: PRINT YOUR LETTERHEAD

1. From the **File** menu choose **Print with Preview.**

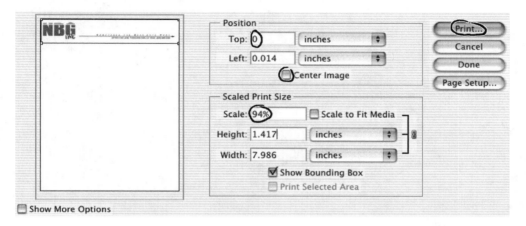

2. Look at your image in the white preview area. If it touches the edge, your printer requires margins that are too large to print this whole image. Set the **Scale** field to **94%** to make it fit.

3. Put a check mark in the **Center Image** check box. Your image is horizontally and vertically centered on the page.

4. Clear the check mark from the **Center Image** check box then set **Top** to **0.** Your image is still horizontally centered but it's now at the top of the printable area of the page.

5. Click **Print.**

6. Finish printing (as seen in Project 13, Procedure 10) and save the file.

RESULT

PROJECT 16

ADVERTISING POSTCARD

CONCEPTS COVERED

- ❏ Custom brushes
- ❏ Tool presets
- ❏ Custom patterns
- ❏ Rotation
- ❏ Polygon shapes
- ❏ Noise gradients
- ❏ Drop shadows

REQUIREMENTS

- ❏ None

RESULT

- ❏ An advertising postcard with a musical theme

PROCEDURES

1. Make a note brush
2. Make a note pattern
3. Make a staff brush
4. Create a star
5. Add a gradient stroke
6. Make a noise gradient
7. Paint music staffs
8. Paint music notes
9. Add shine and shadows
10. Add your ad

PROCEDURE 1: MAKE A NOTE BRUSH

1. Start a new image **3.5 inches** wide, **5.5 inches** high, **200 pixels/inch,** and with **Contents** set to **White.**
2. Set the foreground color to black.
3. Choose the **Ellipse** tool (shortcut: **u**) from the toolbox.
4. Set the **Fill pixels** and **Anti-aliased** options, click the **Geometry options** drop arrow, and set the **Fixed Size** to a **Width** of **.25 in** and a **Height** of **.125 in.**

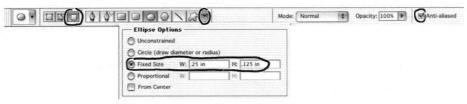

5. Click the ellipse onto your image. If it does not appear, reenter the width and height and try again.
6. On the option bar, click the **Line** tool button. Click the **Geometry options** drop arrow, and make sure both the **Start** and **End** arrowhead check boxes are unchecked. Set **Weight** to **5 px.**
7. Draw a line starting at the right edge of the ellipse and going 3/8 of an inch straight up.

 Remember to turn on rulers (Project 13, Procedure 2) to help you judge 3/8 of an inch and to hold down **Shift** to keep your line straight.

8. Use the **Rectangular Marquee** tool (shortcut: **m**) to select this quarter note you've drawn.
9. From the **Edit** menu, choose **Define Brush.**
10. In the dialog box that appears, enter the name **Quarter note** then click **OK.**

 Don't worry that the brush image looks distorted on the dialog box. It's fine.

RESULT

PROCEDURE 2: MAKE A NOTE PATTERN

1. From the **Edit** menu, choose **Transform, Rotate.**
2. On the option bar, set the **Rotate** value to **45** degrees, then click the check mark. The note is now tilted by 45 degrees.

3. Use the **Rectangular Marquee** tool (shortcut: **m**) to select an area around the tilted quarter note, about twice as high and twice as wide as the note in its current position.
4. From the **Filter** menu, choose **Stylize, Emboss.** A dialog box opens.
5. Set **Height** to **3** pixels and **Amount** to **100%**, then click **OK.**
6. From the **Image** menu, choose **Adjustments, Color Balance.** A dialog box appears.

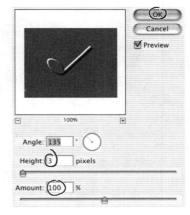

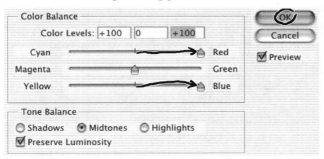

7. Drag the top and bottom sliders all the way to **Red** and **Blue** then click OK.

 This turns the gray image into a purple (red plus blue) one.

8. From the **Edit** menu, choose **Define Pattern.** A dialog box appears.
9. In the **Name** field, enter **Purple note** then click **OK.** Your pattern is now saved!

RESULT

PROCEDURE 3: MAKE A STAFF BRUSH

1. Scroll the history palette back to the very beginning and click **New** to reset the image to its original blank state.

2. Create a new layer then use the **Pencil** tool (shortcut: **b**) with a **Hard Round 9 pixels** brush to click a dot onto the new layer.

3. From the **Layer** menu, choose **Duplicate layer,** and when the dialog box appears, click **OK.** You now have two layers with dots on them, one right on top of another.

4. Repeat step 3 three more times, so that you now have five layers with dots.

5. Using the **Move** tool (shortcut: **v**), drag the top layer down half an inch.

The info palette includes a readout showing how far you've moved the item.

6. Link the five layers (as seen in Project 6, Procedure 4), then click the **Align horizontal centers** and **Distribute vertical centers** buttons on the option bar to end up with a column of five evenly spaced dots.

7. Select the five dots and save them as a brush named **Staff,** using the steps seen in Procedure 1.

Five dots may not look impressive, but if you drag that brush sideways, you create the five parallel lines that make up a musical staff.

PROCEDURE 4: CREATE A STAR

1. Use the history palette to reset to a blank image again (the last time for this project, I promise).
2. Choose the **Polygon** tool (shortcut: **u**) from the toolbox.
3. Click the **Shape layers** option and set **Sides** to **12.**

4. Click the **Geometry options** drop arrow. Put a check mark in the **Star** check box, setting **Indent Sides By** to **80%.** Put a check mark in the **Smooth Indents** check box.

 Indenting the sides makes this a 12-pointed star shape, rather than a 12-side polygon. Smoothing the indents connects the points via curves, rather than jagged lines.

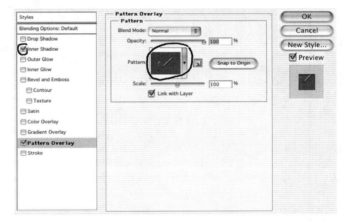

5. Point to the center of the image (that's 2.75 inches down, 1.75 inches across— use your rulers!) and drag straight down to about the 5-inch mark.
6. From the **Layer** menu, choose **Layer Style, Pattern Overlay.** A dialog box appears.
7. From the **Pattern** drop list, select the **Purple note** pattern. Put a check mark in the **Inner Shadow** check box on the left column of styles.

 You can reset the options in this dialog box (and almost every other image-changing dialog box) by holding down the Macintosh **Option** key or the Windows **Alt** key. When you do this, the cancel button turns into a **Reset** button, which you can click to reset the settings.

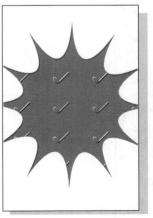

RESULT

PROCEDURE 5: ADD A GRADIENT STROKE

1. On the left side of the layer style dialog box, click **Stroke** (the word, not just the check box). The stroke settings appear.

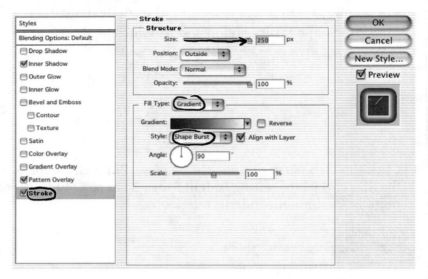

2. Drag the **Size** slider all the way to the right. You want a big stroke!

3. From the **Fill Type** drop menu, choose **Gradient,** and the gradient settings appear.

4. From the **Style** drop menu, choose **Shape Burst.** The gradient now follows the edges of your star shape, making your star glow.

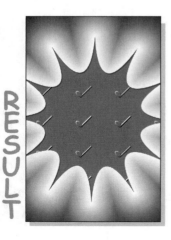

RESULT

PROCEDURE 6: MAKE A NOISE GRADIENT

1. In the layer style dialog box, click on the picture of the gradient (*not* on the drop arrow at the end of the picture, but the picture itself). A gradient editor appears.

2. From the **Gradient Type** drop list, choose **Noise.**

 A *noise gradient* doesn't fade from one color to another. Instead, it sets up a series of randomly selected colors (from within a selected range of colors), creating interesting banded patterns.

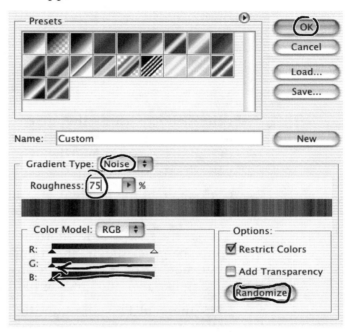

3. Drag the open arrowheads from the right ends of the **G** and **B** lines all the way to the left.

 As you know, RGB colors are each a mixture of a certain amount of red, green, and blue. In choosing colors for the gradient, Photoshop will only pick colors where the green component, for example, is between the level shown by the black arrow and the level shown by the white one. By setting both arrowheads all the way to the left, you make sure the colors don't have any green in them; the same concept applies for blue. This means that all colors are made up of a range of reds, which gives it a dangerous, explosive look.

4. Set roughness to **75%.**

 This sets how many different color bands are used. The higher the number, the more bands.

5. Click **Randomize** repeatedly until you see a pattern you like.

6. Click **OK** on the gradient editor dialog box, then click **OK** on the layer style dialog box.

RESULT

PROCEDURE 7: PAINT MUSIC STAFFS

1. Create a new layer.

2. Using the **Pen** tool (shortcut: **p**) with the **Paths** option selected on the option bar, click one-half inch from the top, just inside the left edge of the image, to start your path.

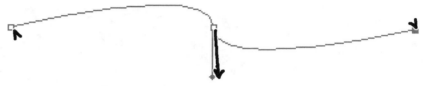

3. Point halfway across the image (still one-half inch from the top) and drag straight down one-half inch. To reach this point, the path curves up and then comes straight down to follow your drag.

4. Click again at the far right of your image, again one-half inch from the top. This is the end of the path.

5. Choose the **Pencil** tool (shortcut: **b**) from the toolbox. On the option bar, click the **Brush** drop list and choose the **Staff** brush from the end of the list. The brush image may be distorted, looking like five little lines or blobs.

6. Click the **Tool Preset** button (the button at the far left of the option bar that shows the current tool's icon). Click the arrow-head button on the list that appears and choose **New Tool Preset** from the menu.

7. A dialog box appears. Set **Name** to **Staff Painter**, clear the **Include Color** option, and click **OK.**

8. Click the arrow button on the upper right of the paths palette, and choose **Stroke Path.** When the dialog box appears, click **OK** to stroke the path with the staff brush.

9. Use the **Path Component Selection** tool (shortcut: **a**) to drag the path down to about one-half inch from the bottom of the image, then repeat step 6 to stroke it again.

10. Click the **Tool Preset** button again and choose **Staff Painter** from the list. This restores the pencil tool with the staff brush and the previous option bar settings. Point halfway down the left side, holding down the **Shift** key (to keep the line straight), and drag across to the right side.

PROCEDURE 8: PAINT MUSIC NOTES

1. Click the **Brushes** tab on the far right of the option bar, or go to the **Window** menu and choose **Brushes** if you don't see it.

2. Click **Brush Presets** then choose the **Quarter note** brush.

 The brush may look distorted but it should be easy to find – it's the next-to-last brush.

3. Click **Brush Tip Shape,** and new settings appear. Make sure the **Spacing** option is checked and set the value to **250%**.

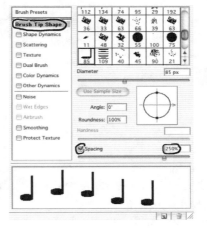

 When you draw with a brush, Photoshop just repeatedly stamps the brush on your image. Normally, the spacing between stampings is a fraction of your brush width, so the individual stampings are so close together that they blur into a single line. By setting the value over 100% of the brush's width, you make sure there's space between the stampings, making each brush image separate and clear.

4. For each staff, starting from the left, drag toward the right, flowing the staff up and down as you do. You leave a trail of notes.

 If you want to place the notes precisely, click, rather than drag each one into place.

5. If you want to save the staff and quarter note brushes, it works just the same way as saving the custom shape in Project 15, Procedure 5. Instead of working on the custom shape list, you're working on the brush list, of course. Delete all of the other brushes, save the remaining brush set, then reset the brush list to restore the standard brushes.

 The technique of holding down the **Alt** or **Option** key while clicking to delete items works not only on this list, but also on other custom lists, such as the shape list and the styles list.

RESULT

PROCEDURE 9: ADD SHINE AND SHADOWS

1. From the **Layer** menu, choose **Layer Style, Drop Shadow.** A dialog box appears.

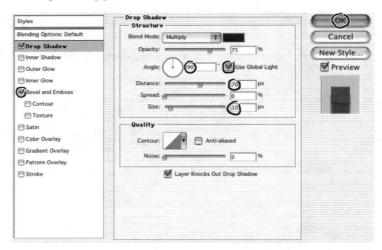

2. Put a check mark in the **Bevel and Emboss** check box. This creates highlights on the staffs, making them look three-dimensional.

3. Set the **Angle** to **90** degrees, and make sure that the **Use Global Light** option is checked.

 The global light option means that the same lighting angle is being used for the shine created in step 2 as it is for the shadow being created here. That creates a realistic effect, as if the shine and the shadow are created by the same light.

4. Set **Distance** to **70.**

 This is the distance between the object and the shadow it casts. The bigger the distance, the higher it seems that the object is above the background.

5. Set **Size** to **10.**

This variable is used to blur the shadow, with a higher value meaning more blur. With the size set to zero, the shadow just looks too sharp, as if it were cast by an impossibly precise light source.

6. Click **OK.**

PROCEDURE 10: ADD YOUR AD

1. Set the foreground color to white, then choose the **Horizontal Type** tool (shortcut: **t**) and reset the tool.
2. On the option bar, set the **Font** to **Impact,** the **Font Size** to **36 pt,** and click the **Center text** option.
3. Click on your image just above the center of the middle staff and type **QUARTER NOTES.** Press **Enter** or **Return** twice then type **ON SALE: 5 FOR $1.**
4. If you're using a Macintosh, hold down the **Ctrl** button while clicking on the text. If you're using Windows, right-click on the text. In either case, choose **Warp Text** from the menu that appears.
5. In the dialog box, set the **Style** to **Bulge** and **Bend** to **+65%** then click **OK.**

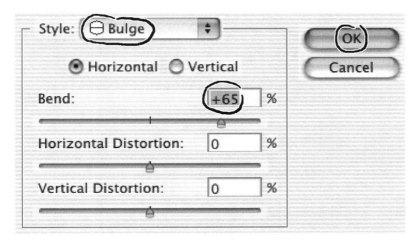

6. Use the **Move** tool (shortcut: **v**) to slide the text so that it's centered horizontally and vertically.
7. On the layers palette, set the text layer's **Blending mode** to **Exclusion** instead of Normal. The color beneath the text is subtracted from the white color of the text, creating an inverted color effect.
8. Use a layer style to put a thin black stroke around the text.
9. Save your image.

RESULT

PROJECT 17
MATCHED MINI MASTERPIECES

CONCEPTS COVERED

❏ Smudge tool
❏ Texture effects
❏ Brush dynamics
❏ Duplicating an image
❏ Prerecorded actions
❏ Image flipping

REQUIREMENTS

❏ None

RESULT

❏ A pair of pictures of framed art

PROCEDURES

1. Make a sunset
2. Heatwave!
3. Grow a tree
4. Raise some grass
5. Make a mirror image
6. Create a painted appearance
7. Create texture
8. A wooden picture frame
9. Create neon
10. A plastic picture frame

PROCEDURE 1: MAKE A SUNSET

1. Start a new **RGB Color** mode image **3 inches** wide, **3 inches** high, **72 pixels/inch,** with **Contents** set to **White,** and name it **Tropical Sunset.**

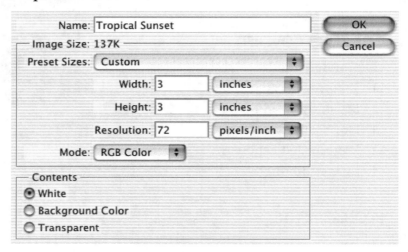

2. Set the foreground to pink and the background to red.

3. Fill the image with a foreground-to-background gradient, as shown in Project 2, Procedure 6. The image should be red at the top and turn pink as it goes down.

4. Use the **Ellipse** tool (shortcut: **u**) to draw a yellow circle about half the height of your image in the center of your background.

Don't try to make it exactly half the height or exactly centered. You want your image to look like it was painted by a human, not generated by a machine. Off-center is good. (Similarly, if you see any typos or mistakes in this book, it's not because I made an accidental error. I've put them in there on purpose to make sure that the book had a human feel to it. After all, what is more human than to errr?)

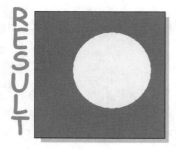

PROCEDURE 2: HEATWAVE!

1. Choose the **Smudge** tool (shortcut: **r**) from the toolbox.

2. On the option bar, select a **Hard Round 13 pixels** brush and set **Strength** to **20%**.

 You're about to smudge the colors around to create the rippling-atmosphere effect that you can see on hot days. You don't want to smudge things around too much, though. With a low resolution picture, a little smudge goes a long way. By keeping the pressure low, you keep from smudging too far.

3. Drag your mouse from side to side across the sun, starting at the top and working your way down. The colors smear somewhat, giving the sun a shimmering effect.

PROCEDURE 3: GROW A TREE

1. Create a new layer.

 You're going to use a filter on what you create here, and you don't want that filter to change the background. Using a separate layer is the easiest way to handle this.

2. Set the foreground color to brown.

3. Get the **Pencil** tool (shortcut: **b**), then click the **Brush** drop list on the option bar. Choose a hard round brush, then set **Master Diameter** to **35 px.**

 Adjusting the master diameter changes the size of the brush. Some brushes get rough edges when you resize them, but round brushes stay smooth.

4. Draw a line up the image toward one side but not touching the edge.

 Don't hold down shift to try to make the line straight. This is supposed to be a tree trunk—a natural object.

5. From the **Filter** menu, choose **Texture, Texturizer.** A dialog box appears.

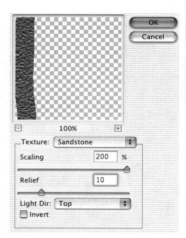

6. Set **Texture** to **Sandstone, Scaling** to **200%, Relief** to **10** and click **OK.** This changes the tree color from solid brown to a mottled color, more like a real tree trunk.

 If you can't see the tree in the pre-view area of the dialog box, point to the preview area and drag. This moves the image within the preview area. (You could also zoom out by pressing the – button below the left side of the preview area.)

7. From the **Layer** menu, choose **Flatten Image** to merge this layer into the background.

PROCEDURE 4: RAISE SOME GRASS

1. Set the foreground color to a very dark green and the background color to a medium-light green.

2. Choose and reset the **Brush** tool (shortcut: **b**).

3. As you did in Project 16, Procedure 8, open the **Brushes** palette and select a **Hard Round 9 pixels** brush.

4. Click **Shape Dynamics**. In the **Size Jitter** area set the **Control** drop menu to **Fade** and enter **50** in the field to the right.

 With this setting, as you drag the brush, the tip gets smaller every time it has to stamp the brush image. After 50 stampings, the brush size reduces to nothing. This lets you drag a shrinking trail.

5. Click **Color Dynamics**, then set **Control** to **Fade**, with **50** in the field.

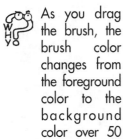 As you drag the brush, the brush color changes from the foreground color to the background color over 50 stampings.

6. Point the cursor about one-half inch above the bottom of the image and drag upward. A single blade of grass appears.

7. Draw more blades of grass this way, making a full row of grass starting half an inch off the bottom of the image. Again, don't strive for precision. Grass is random.

8. Draw two more rows of grass blades, one starting one-quarter inch above the bottom of the image, and one starting at the bottom of the image.

RESULT

PROCEDURE 5: MAKE A MIRROR IMAGE

1. From the **Image** menu, choose **Duplicate.** A dialog box appears.

2. In the **As** field, type **Neon Sunset**—the name for the new image.

3. Click **OK.** A new window opens up with a second copy of your image.

4. From the **Image** drop menu, choose **Rotate Canvas, Flip Canvas Horizontal.** The Neon Sunset image is now a mirror image of the Tropical Sunset image.

5. From the Window menu, choose Document, Tropical Sunset. The original picture now comes to the front. (That's the one you'll be working on for the next few procedures.)

PROCEDURE 6: CREATE A PAINTED APPEARANCE

1. From the **Filter** menu, choose **Noise, Add Noise.** A dialog box appears.

2. Set the **Amount** to **20%** and the **Distribution** to **Uniform.** Turn off the **Monochromatic** option then click **OK.**

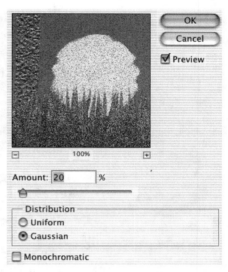

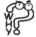 You're adding speckles to this image so that you can smear them about a bit, creating the look of brush-strokes. If we left areas like the sun a solid color, then when we smeared, there would be no sign of the smearing—it would all still be a solid yellow.

3. From the **Filter** menu, choose **Brush Strokes, Angled Strokes.** A dialog box appears.

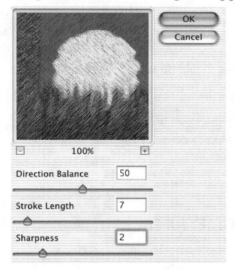

4. Set the **Direction Balance** to **50,** the **Stroke Length** to **7,** and the **Sharpness** to **2.**

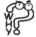 The direction balance controls what portion of the picture is depicted with downward brushstrokes, versus what portion is depicted with upward brushstrokes. With the low resolution of the image, it's best to keep the stroke length relatively small.

5. Click **OK.** The image now looks like the paint is smeared into place.

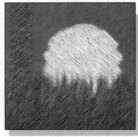

RESULT

PROCEDURE 7: CREATE TEXTURE

1. From the **Filter** menu, choose **Texture, Texturizer.** A dialog box appears.

2. Set the **Texture** drop menu to **Canvas.**

 You're trying to make this look like it was painted on canvas.

3. Set **Scaling** to **100%** and **Relief** to **1.**

 This setting is how raised the texture is. On a low-resolution image like this, you want a low value. Otherwise, the texture overwhelms the image. The texture of canvas should be subtle.

4. Set **Light Dir** to **Bottom Right.**

 Later, you'll add a different effect that will make it look like the light is coming from the bottom right. If you don't keep the light source consistent, the image will look less real.

5. Click **OK.**

A DEEPER UNDERSTANDING: TEXTURES

Obviously, your image doesn't actually have a texture. If you feel your computer screen, your screen is as flat as ever, but now you've got fingerprints all over it. Photoshop creates the illusion of texture by pretending some parts of your image are raised. The program lightens the edge of the area that the light is shining on and darkens the edge that's in the shadow.

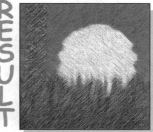

Any Photoshop image can be used as a texture. To design your own texture, just create a Photoshop image with the brightest areas being the ones you want raised and the darkest areas being the ones you want to be lower. Save the image. To use this texture, take the steps you see in this procedure, but instead of choosing Canvas from the **Texturizer** field, choose **Load Texture.**

PROCEDURE 8: A WOODEN PICTURE FRAME

1. On the actions palette, click the arrow button in the upper right-hand corner and choose **Frames.atn** from the list that appears. This loads a prerecorded set of frame-making actions onto the actions palette.

2. On the list on the actions palette, there is now an entry named **Frames.atn.** Below that a list of types of frames appears. Click the **Wood Frame—50 pixel** entry then click the **Play selection** button.

3. A dialog box warns you that this frame only works if your image is at least 100 pixels in each dimension. Because your image is 216 pixels in each dimension, you're fine. Click **Continue** and watch as Photoshop goes through a series of steps in building your frame.

4. Save your image.

 When you do the **Save** command, **Tropical Sunset** will already be entered as the name for your image because you named the image when you created it.

A DEEPER UNDERSTANDING: ACTION SETS

Photoshop comes with a number of prerecorded action sets, each of which is listed on the actions palette's menu. These actions are recorded and played in the same way you recorded and played your action in Project 8. They're all worth experimenting with.

Better yet, you can see how all these actions are done! Click the arrowhead symbol next to an action name, and the steps that make up that action are listed below it. Click the arrowhead button next to a step, and the settings for that step are listed. There is a lot you can learn by looking carefully at how these actions work.

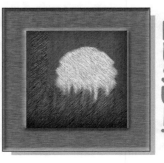

RESULT

PROCEDURE 9: CREATE NEON

1. From the **File** menu, choose **Close** to close the Tropical Sunset image. This leaves the Neon Sunset image open.

2. From the **Filter** menu, choose **Brush Strokes, Ink Outlines.** A dialog box appears.

3. Set **Stroke Length** to **4, Dark Intensity** to **20,** and **Light Intensity** to **10** then click **OK.**

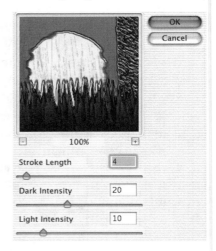

 You won't see the ink outlines in the final result. However, adding them here makes the image a little more complex, which will give you better results from the next filter you use.

4. From the **Filter** menu, choose **Stylize, Glowing Edges.** A dialog box appears.

5. Set **Edge Width** to **2, Edge Brightness** to **6,** and **Smoothness** to **6** then click **OK.** The image will now be black, with glowing outlines around the shapes.

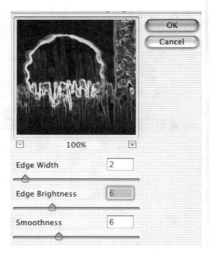

RESULT

PROCEDURE 10: A PLASTIC PICTURE FRAME

1. On the actions palette, click the **Foreground Color Frame** entry, then click the **Play selection** button.

2. A dialog box appears warning you of this action's size limitation. Click **Continue.**

3. Photoshop does some work, then another dialog box opens asking you to choose a foreground color. Click **Stop.**

4. Set the foreground color to the color you want the frame to be.

> **TIP** A neon picture goes well with a black frame or with unnatural colors such as rich purples or blues.

5. Click the action palette's **Play selection** button again. Photoshop finishes building the frame.

6. Save the Neon Sunset image. You now have a bizarre modern image to go with your more painterly Tropical Sunset.

. .

A DEEPER UNDERSTANDING: SNAPSHOTS

Before you close this image, open the history palette and scroll to the top of its list. There you'll see a thumbnail of the unframed version of this image titled Snapshot 1. What's this?

Due to memory limitations, Photoshop can remember a handful of recent commands. You can't use the *undo* or *step backward* commands to step further back than that. Realizing that you might want to undo the entire framing process, the framing action starts by taking a snapshot of your image's state. Photoshop allocates memory to store that state even after later commands scroll away. Click on the snapshot thumbnail to return the image to that state.

You can take your own snapshot of your image at any time. Just click the **Create new snapshot** button at the bottom of the history palette. That way you can experiment with the image knowing that you can still undo anything disastrous by reverting to the snapshot.

R
E
S
U
L
T

PROJECT 18

WEB BACKGROUND AND LOGO

CONCEPTS COVERED

- ❏ Rotating characters
- ❏ Tiling images
- ❏ Tile Maker filter
- ❏ Patterns in ImageReady
- ❏ Trimming

REQUIREMENTS

- ❏ None

RESULT

- ❏ A Web page background design with a matching logo

PROCEDURES

1. Get a safe background
2. Rotate some characters
3. Spin gerbils
4. Make your tile
5. Save your tile
6. Start the logo
7. Fill with your tile
8. Test and save your logo

PROCEDURE 1: GET A SAFE BACKGROUND

1. Start up ImageReady.
2. Click the arrow button on the upper right of the color palette and choose **Web Color Sliders** from the menu that appears.

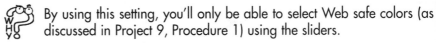 By using this setting, you'll only be able to select Web safe colors (as discussed in Project 9, Procedure 1) using the sliders.

3. Click the background square on the color palette, then set the **R** drop list to **66**, the **G** drop list to **FF**, and the **B** drop list to **66**.

4. From the **File** menu, choose **New**.

5. Set both **Width** and **Height** to **150**, set **Contents of First Layer** to **Background Color**, then click **OK**.

6. Use the color palette to set the foreground color with **R** set to **66**, **G** set to **CC**, and **B** set to **66**.

. .

A DEEPER UNDERSTANDING: WEB COLOR NOTATION

When you set the sliders to RGB mode, you can set each color component anywhere from 0 to 255. When you set them to CMYK mode, you set them between 0 and 100. But in this Web color mode, the values range from 00 to FF. What's up with that?

You're really setting values from 0 to 255. However, Web colors are tracked not with decimal numbers, but with *hexidecimal* numbers, which is the way people would count if they had 16 fingers. In this system, you count 00 to 09, but then you count 0A (which is the same as the decimal value 10), 0B, 0C, 0D, 0E, 0F (which would be 15 in decimal). Then you count 10 (decimal 16) to 1F (decimal 31), 20 to 2F, and so on, until you get to FF (decimal 255).

When a color value is stored in an HTML file, it's stored in the form *#F0132C*, where *F0* is the red value, *13* is the green value, and *2C* is the blue value.

PROCEDURE 2: ROTATE SOME CHARACTERS

1. Choose the **Type** tool (shortcut: **t**) from the toolbox.

2. Point to the **T** at the far left of the option bar and press down the mouse button. Choose **Reset All Tools** from the menu that pops up.

3. Set the font to **Arial Black,** the size to **12 px, Anti-aliasing method** to **Smooth,** with the **Right align text** option.

4. Open the character palette and set **Horizontally Scale** to **150%** and click the **Color** drop list and select **Foreground Color.**

5. Click the pointer near the upper-right corner and type PUPPIES.

6. Click twice in the lower-right corner.

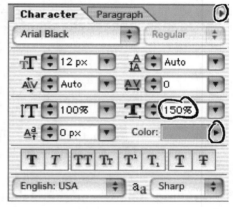

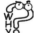 The first click tells ImageReady that the previous text layer is done. (ImageReady doesn't have the check mark to click the way Photoshop does.) The second click creates a new text layer.

7. Click the drop arrow button in the upper right of the character palette. Choose **Change Text Orientation** from the menu that appears. From the same menu choose **Rotate Characters** and **Faux Italic.**

8. Type **Snakes.**

9. Click twice at the horizontal center of the bottom of the image.

10. On the character palette, set **Horizontal Scale** to **250%**. Click the arrow button and choose **Rotate Character.** Type CATS.

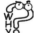 The rotate character option only works with vertically oriented text. Each character is horizontally oriented; the text is just stacked.

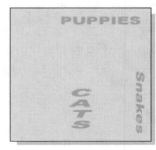

PROCEDURE 3: SPIN GERBILS

1. Click twice on the center of the left side of the image.

2. Click the **Change text orientation** and **Left align text** buttons on the option bar.

3. Type **GERBILS**.

4. Use the technique from Project 16, Procedure 2 to tip GERBILS to a **315**-degree angle.

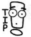 The angle figure is always assumed to be a *clockwise* angle. To rotate an item *counterclockwise*, you can either subtract the degrees amount of rotation from 360 (360 − 45 = 315) or simply enter a negative number (such as −45).

5. Use the **Move** tool (shortcut: **v**) to move GERBILS so that it touches the left edge of the image.

6. Select the **Text** tool and click the **Warp Text** button on the option bar.

7. In the dialog box that appears, set **Style** to **Shell Upper** and **Bend** to **35%** then click **OK**.

. .

A DEEPER UNDERSTANDING: WEB BACKGROUND COLORS

The color scheme of this design is drab, but there's a reason for that. This image is meant to be used as background on a Web page. In the early days of the Web, people went nuts with their backgrounds, with full-color photos and pictures of swirling galaxies. Although the images were interesting, you couldn't read the text on those Web pages. If you could read the letters against the brighter parts of the image, you couldn't make them out against the darker parts.

These days, most Web sites use solid-color backgrounds rather than graphic designs. The sites that use background images well either make the image all light colors (so they can put dark text in front of them) or all dark colors (for light text). You don't have to have the entire background be the same hue, like the two colors of green used in this example, just the same amount of brightness.

PROCEDURE 4: MAKE YOUR TILE

1. From the **Layer** menu, choose **Flatten Image.** The various layers are all turned into one flat layer.

2. From the **Filter** menu, choose **Other, Tile Maker.** A dialog box appears.

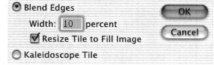

Whenever you want to use this filter, you'll have to use ImageReady. Unlike most filters, it's not available in Photoshop.

3. Select the **Blend Edges** and **Resize Tile to Fill Image** options, and set the **Width** to **10.**

4. Click **OK.** The entire image is expanded, with the material at the edges wrapping around to the other side and fading into the image that was already there.

5. From the **File** menu, choose **Output Settings, Background.** A dialog box appears.

6. Set the **Settings** drop list to **Background Image,** and set the drop list below that to **Background;** set the **View As** option to **Background** then click **OK.**

7. From the **File** menu, choose **Preview in** and then select a browser from the submenu. The image appears as a tiled background in that browser, which also displays the HTML code needed to use the background.

You can also perform this command by clicking the **Preview in Default Browser** button in the toolbox, or by right-clicking (Windows) or clicking with ctrl key held down (Macintosh) on the image, and choosing **Preview in** from the menu that appears.

RESULT

PROCEDURE 5: SAVE YOUR TILE

1. Close your Web browser to return to ImageReady.

2. On the optimize palette, set the **Settings** to **JPEG High.**

3. From the **File** menu, choose **Save Optimized.** Using the file browser that appears, select a location for your files, set **Format** to **Images Only,** set the **Name** to **pet-back.jpg,** then click **Save.**

4. From the **Edit** drop menu, choose **Define Pattern.** A copy of your image is stored as a pattern.

 You're going to use this pattern as part of another image. ImageReady handles patterns a bit differently than Photoshop. You can't name them or save them. You only get one user-defined pattern at a time.

5. From the **File** menu, choose **Close** to close the image window.

A DEEPER UNDERSTANDING: TILES

A *tile* is simply an image that is designed to repeat. If you take most images and build a big grid with just copies of that image, you'll see where each copy ends and the next begins. Often there will be a very hard line where the color at the bottom of the image doesn't match the color of the top of the image in the copy below.

When you have an image that's designed as a tile, however, you can see that the image repeats, but there is no line marking the end of one image and the beginning of the next. Tiles are used as Web page backgrounds, as computer desktop wallpaper, and as patterns for filling other images. The tilemaker filter turns almost any image into a usable tile by blending the top and bottom of the image together and by blending the sides together.

RESULT

PROCEDURE 6: START THE LOGO

1. Start a new image, with a **Width** of **300** pixels, a **Height** of **100** pixels, and the **Contents of the First Layer** set to **Transparent.**

2. Choose the **Type** tool and set the **Font** to **Arial Black,** the **Size** to **96 px** and **Anti-aliasing method** to **None.**

 Anti-aliasing works by averaging the color of the edge pixels with the color of the image background. At this point, the image is on a transparent background, and it has no way of knowing what color the Web page background will be that it will have to blend with. If you were to save this image as a PNG format file, the file would have partially transparent pixels around the edge, so that the Web browser would do the job of mixing the edge pixels with the background. Unfortunately, although most modern Web browsers can read PNG files, many of them don't properly handle the partially transparent pixels.

3. On the character palette, set **Horizontally Scale** to **100%, Tracking** to **−150,** and turn on **Faux Italic** and **Faux Bold.**

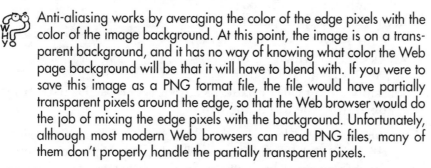

 Tracking, as you may recall, adjusts the amount of space between the letters. By setting it to a large, negative number, you eliminate the space between the letters, so that they actually touch.

4. Type **PETS** into the image window.

5. From the **Image** menu, choose **Trim.** A dialog box appears.

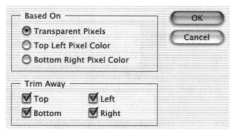

6. Select the **Transparent Pixels** option and make sure all of the **Trim Away** check boxes are checked then click **OK.** The blank edges of the image are trimmed away.

RESULT

PROCEDURE 7: FILL WITH YOUR TILE

1. From the **Layer** menu, choose **Layer Style, Pattern Overlay.** A pattern appears on your letters, although it's not the pattern you want. A pattern overlay palette appears.

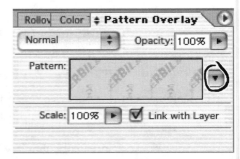

2. Click the **Pattern** drop arrow and a list (quite possibly a long list) of patterns appears. Choose **User-Defined Pattern** from the top of the list.

 When you get a chance, explore these patterns. There are some interesting and useful ones. The ImageReady patterns have lower resolution than the Photoshop patterns. Some of them have transparent sections, letting the color of your image show through the pattern.

3. From the **Layer** menu, choose **Layer Style, Color Overlay.** The pattern you just chose probably disappears as PETS becomes a single solid color. A color overlay palette appears.

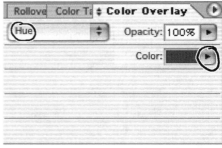

 All layer styles can be selected using the *Add a layer style* button on the layers palette.

4. Set **Blend Mode** to **Hue** and set **Color** to a strong blue.

 The hue blend mode keeps the levels of brightness of your layer, just changing the basic color to the color you select. This gives you a blue version of the pattern.

5. From the **Layer** menu, choose **Layer Style, Inner Shadow.**

 This is not only a nice effect, but by darkening some edges of the letters, you help color-blind people to be able to see your image against the similarly bright background you've designed.

PROCEDURE 8: TEST AND SAVE YOUR LOGO

1. On the optimize palette, set the **Settings** to **GIF 32 No Dither.**

2. From the **File** menu, choose **Output Settings, Background.** A dialog box appears.

3. Make sure the drop list *under* the **Settings** drop list is set to **Background** and **View As** is set to **Image,** then click **Choose.**

4. Using the file browser that appears, locate and select your **pet-back.jpg** file then click **Open.**

 This sets that image as the background image for your Web page.

5. Click **OK.**

6. Preview your image just as you did in Procedure 4.

7. From the **File** menu, choose **Save Optimized As.** Using the file browser that appears, select the same location where you stored your background image, set **Format** to **HTML and Images,** set the **Name to petslogo.gif,** then click **Save.**

8. A dialog box warns you that you're about to replace your pet-back.jpg file (because it's trying to put all of the related files into this directory, even though that one is already there). Clear the **pet-back.jpg** check mark (no need to replace the file with itself), then click **Replace** (because that's the only choice that will complete your save).

9. Save a copy of your file in the Photoshop format.

RESULT

PROJECT 19
TV SCREEN

CONCEPTS COVERED

❏ Creating style layers
❏ Dodge
❏ Burn
❏ Web photo gallery

REQUIREMENTS

❏ You'll need a digitized photograph (reusing one you used earlier should be fine). It would help if you had a couple of Photoshop images in a directory, but it's not absolutely necessary.

RESULT

❏ A simulated TV picture and a Web page cataloguing this and other images

PROCEDURES

1. Trim your picture
2. Put a bug on your screen
3. Hollow out the bug
4. Create the smallest pattern
5. Create scan lines
6. Add an annoying light shine
7. Expand your image
8. Draw a frame
9. Make your image museum
10. Explore your museum

Procedure 1: Trim your picture

1. Open up a digital photo. In my examples, I'm using the Martian "photo" I created in Project 4, but any digital photo should do.

2. From the **Image** menu, choose **Image Size.** A dialog box opens.

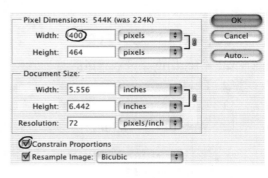

3. Put a check mark in the **Constrain proportions** check box so that you don't distort the image while resizing it. Set the **Width** to **400 pixels** and the **Height** is automatically recalculated to keep the proportions. If the **Height** is less than 300 pixels, set it to **300 pixels,** and the **Width** will be recalculated to match. Click **OK.**

> You want a 400 × 300 pixel image that displays as much as possible of your existing picture. This step makes one dimension right and the other at least the right size, if not bigger.

4. Choose the **Crop** tool (shortcut: **c**) from the toolbox. On the option bar, set the **Width** to **4 in,** the **Height** to **3 in,** and the **Resolution** to **100 pixels/inch.**

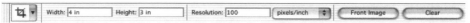

> This 4-to-3 aspect ratio matches the dimensions of standard North American TVs.

5. Starting at the upper-left corner, drag down and to the right. As you do, an area of the proper ratio becomes highlighted. Keep dragging until the highlighted area hits the right edge or the bottom of your picture, whichever comes first.

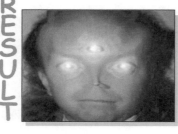

6. Point inside the highlighted area and drag. The highlighted area moves. Position the area over the most interesting portion of your picture.

7. Double-click in the highlighted area. The image is cropped.

PROCEDURE 2: PUT A BUG ON YOUR SCREEN

1. Choose the **Custom Shape** tool (shortcut: **u**) from the toolbox.

2. On the option bar, click the **Shape layers** option then pull down the **Shape** drop list. If the logo you created in Project 15 is there, skip to step 5.

 If you didn't do Project 15 or didn't save your logo, skip to step 5 and just use some other custom shape.

3. Click the arrow button on the upper-right corner of the shape list and choose **My shapes.csh** from the list that appears.

4. A dialog box asks you if you want to replace the current shapes. Click **Append**.

5. Select your logo from the **Shape** drop list.

6. Click the **Geometry options** button on the option bar and choose the **Defined Proportions** option.

7. Drag your logo into place in the lower right of your image. Don't make it very big.

This is just supposed to be a *bug*, which is the official term for those annoying little channel identifier logos that appear right over the program you're watching, distract-ing from whatever you want to see. As if you didn't know what channel you were watching! Oooh, TV makes me so mad, I'm gonna go watch *radio!*

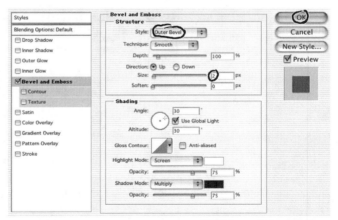

8. From the **Layer** menu, choose **Layer Style, Bevel and Emboss.** A dialog box appears.

9. Set **Style** to **Outer Bevel** and **Size** to **2 px** then click **OK**.

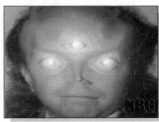

PROCEDURE 3: HOLLOW OUT THE BUG

1. From the **Layer** menu, choose **Layer Style, Create Layers.** Photoshop puts the design created by the layer style onto a separate layer. Actually, the design is split over two separate layers—one layer has the shadows on the dark edges of the shape, while the other has the highlights on the lit edge of the shape.

2. From the **Layer** menu, choose **Delete, Layer**, and click **Yes** on the dialog box that appears.

 TV bugs are almost always hollow inside. This step deletes the colored shape, leaving only the highlights and shadows from the layer style to suggest the shape.

3. On the layers palette, select the **Shape 1's Outer Bevel Highlights** layer.

4. Adjust the **Opacity** setting until you find a level where the bug is visible, but not too bold.

 If your image's color is rather light in the lower-right corner, don't worry too much about trying to make the highlights visible. Against a light background, your bug will be better defined by the shadows.

5. Select the **Shape 1's Outer Bevel Shadows** layer and adjust its opacity.

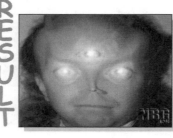

PROCEDURE 4: CREATE THE SMALLEST PATTERN

1. From the **File** menu, choose **New** and create an image that is **1 pixel** wide and **2 pixels** high, with **Contents** that are **Transparent.**

2. Choose the **Zoom** tool and click the **Fit On Screen** button on the option bar. The image becomes a little bigger, although it's still too small to take up all the space of even the smallest possible image window.

 Normally, when you use the Fit On Screen button, your window on the image expands to fill the available space. Photoshop does have its limits, and it refuses to expand any image to more than 16 times its normal height and width. When the image you start with has only 2 square pixels, that still doesn't make it very big.

3. Choose the **Single Row Marquee** tool (no shortcut) from the toolbox and reset the tool.

 This tool and its cousin, the Single Column Marquee tool, aren't used very often, but when you need them, they're perfect. They select a 1-pixel-wide column or row on your image.

4. Click on your 2-pixel image. Half of the image (it doesn't matter which half) is selected.

5. Set the foreground color to black and use the **Paint Bucket** tool (shortcut: **g**) to fill the selected pixel.

6. From the **Select** menu, choose **Deselect.**

7. From the **Edit** menu, choose **Define Pattern.** In the dialog box that appears, name the pattern **Alternating lines** then click **OK.**

8. Close this image without saving it.

RESULT

PROCEDURE 5: CREATE SCAN LINES

1. Select the top layer of your TV image.

2. Click the **Create new fill or adjustment layer** button on the bottom of the layers palette. Choose **Pattern** from the list that appears.

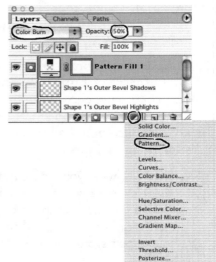

3. In the dialog box that opens, click the drop list at the left and choose the pattern you created then click **OK.** The pattern fills a new layer, creating lines of black alternating with transparent lines that show the image below.

 TV images are made up of *scan lines,* which are rows of dots that show off the image. These lines have slim spacing between them. You are creating the suggestion of those lines.

4. On the layers palette, set the **Blending mode** to **Color Burn** and the **Opacity** to **50%.**

Color Burn is a mode that darkens the dark areas of the image. You don't want to make these lines completely dark, only darker.

5. Click the **Create new fill or adjustment layer** button again, and choose **Brightness/Contrast** from the list. A dialog box appears.

6. Set **Brightness** to **+25** then click **OK.** This brightens up the image somewhat to balance out the darkening caused by the earlier color burn. The end result is not a perfect color re-creation, which accurately reflects the typical television!

7. From the **Layer** menu, choose **Flatten Image.** All of the layers are combined into a single background.

PROCEDURE 6: ADD AN ANNOYING LIGHT SHINE

1. Get the **Dodge** tool (shortcut: **o**) from the toolbox.

2. On the option bar, select the **Soft Round 9 pixels** brush tip and set exposure to **50%**. If the upper-right corner area of your image is basically dark, set **Range** to **Shadows.** If it's basically light, set **Range** to **Highlights.** If it's in-between, set **Range** to **Midtones.**

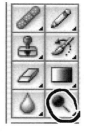

 Dodge is the opposite of *Burn*. Dodge makes colors lighter. If you were using the Color Dodge blending mode, it would only make the light colors lighter. When you're using the dodge tool, however, you can choose whether you're mainly making dark colors (shadows) lighter, or light colors (highlights), or in-between (midtones). There are similar settings for the burn tool that shares the dodge tool's spot in the toolbox.

3. On the upper-right corner of your image, paint a 1-inch line that's curved toward the top and straight down below that. This is supposed to be a badly placed light reflecting off your TV screen, with the slight curvature suggesting the curve of the screen itself. If you keep stroking over the area, it gets brighter.

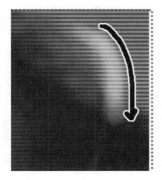

RESULT

PROCEDURE 7: EXPAND YOUR IMAGE

1. From the **Image** menu, choose **Canvas Size.** A dialog box appears.

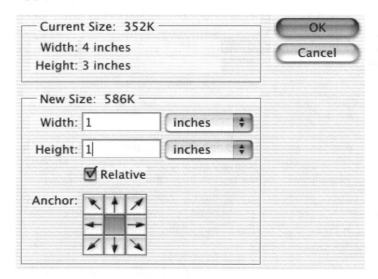

Current Size: 352K
- Width: 4 inches
- Height: 3 inches

OK
Cancel

New Size: 586K
- Width: 1 [inches ▾]
- Height: 1 [inches ▾]
- ☑ Relative
- Anchor:

2. Put a check in the **Relative** check box.

This tells Photoshop that the dimensions you're about to enter are how much bigger you want the image to become, rather than the image's final size.

3. Set **Width** to **1 inch** and **Height** to **1 inch,** with the **Anchor** in the center.

4. Click **OK.** An extra one-half inch of blank space appears around the image.

5. From the **Image** menu, choose **Canvas Size** again.

6. Set **Height** to **.25 inch,** with the **Anchor** at the top and click **OK.** This adds an extra quarter inch to the bottom of the image to reflect the fact that most TV sets are bigger at the bottom than at the other edges.

RESULT

PROCEDURE 8: DRAW A FRAME

1. Set the foreground color to black.

2. On the layers palette, click the **Create new fill or adjustment layer** button and choose **Solid Color** from the menu that appears. When the color picker opens, click **OK.** A layer filled with black covers up your image.

3. On the layers palette, lower the opacity so that you can see the video image through the black layer.

4. Choose the **Rounded Rectangle** tool (shortcut: **u**) from the toolbox.

5. On the option bar, choose the **Fill pixels** option and set **Radius** to **10 px.**

6. Drag the rectangle into place, covering over the video image. This is actually painting on the layer mask to reveal the image.

If you can't cover the image exactly, it's better not to cover the edges of the image than to cover too much. In any case, you won't be covering the corners of the image because the rectangle you're drawing has rounded corners.

7. On the layers palette set **Opacity** to **100%.**

8. From the **Layer** menu, choose **Layer Style, Inner Glow.** Set the size to **9** pixels and click **OK.** A slight glow appears, simulating the glow of the TV image against its case.

9. Spend some time thanking the amazing innovators who have removed all controls from the TV, thus making your image easier to draw. Now all the controls are on your remote, which would be very handy if you could actually find it.

10. Save this image in the same directory as your mini masterpieces from Project 17. Name it **TV.**

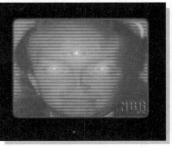

RESULT

PROCEDURE 9: MAKE YOUR IMAGE MUSEUM

1. From the **File** menu, choose **Automate, Web Photo Gallery.** A dialog box appears.

2. From the **Styles** drop list, choose **Vertical Frame.** From the **Options** drop list, choose **Large Images.** Put a check mark in the **Resize Images** check box, and set both **Resize Images** and **JPEG Quality** to **Medium.**

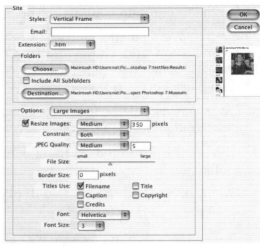

3. Click the **Choose** or **Browse** button. A file browser appears.

4. Navigate into the folder that holds the folder with the images. (*Don't* navigate into the folder with the images themselves, but the next level up.) Click the name of the folder then click **Choose.**

5. Clear the **Include All Subfolders** check box then click **Destination.**

6. Another file browser appears, displaying the same directory that you navigated to with the old one. Navigate to a folder that's not inside the folder with the images.

7. The museum folder is now selected in the file browser. Click **Choose** or **OK** to close the file browser.

8. Click **OK** on the main dialog box. Photoshop spends some time creating JPEG versions of all the graphic files in your source folder, then it opens up your Web browser to display your work!

R E S U L T

PROCEDURE 10: EXPLORE YOUR MUSEUM

1. In your photo gallery, there are small versions of each of your images on the left. Depending on how many images you had in that directory, you may have too many to fit on the screen. Use the scroll bar besides the images to scroll through until you find the small version of the TV image.

2. Click the small version of the TV image and a larger version appears on the right.

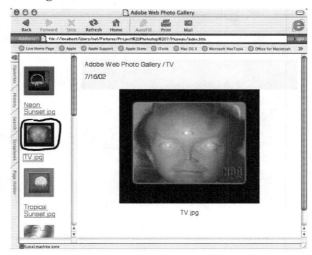

3. When you're done looking at your images, go to the **File** menu and choose **Quit** or **Exit** to close your Web browser.

 The *photo gallery* (a silly name because it's not limited to photos) is still on your hard disk. You can open it up at any time by navigating to the destination directory you chose and opening the file **frameset.htm** with your Web browser.

A DEEPER UNDERSTANDING: GALLERY SETTINGS

Obviously, there are a variety of options to choose from when setting up your photo gallery. There are different layouts for the gallery, including non-frame ones, which will work with older browsers. On the dialog box, there are several different sets of options. Set **Options** to **Banner** to create a name for your gallery and to put your own name there. Set **Options** to **Thumbnails** to adjust the size of the small versions of the pictures, the fonts used on the file names, and other such items. Set **Options** to **Custom Colors** to change the colors of the background and the text, and to **Security** to set information to embed in the picture.

Even on the options you did set in this project, there was one choice that may not have been the best. By selecting the **Resize Images** option, you made Photoshop increase the size of the mini masterpieces and decrease the size of the TV images. These steps make the images less sharp. The reason I had you use these images is that you may have had the results of some of the other projects in there, including ones that may have been too big to display in the Web browser. Resizing the images prevents that problem.

RESULT

PROJECT **20**

YOUR DIPLOMA

This certifies that all twenty projects in the book *Project: Photoshop 7* have been properly completed by

Nat Gertler

who shall be accorded all appropriate rights, privileges, and peanut butter sandwiches.

CONCEPTS COVERED

- ❑ Notepaper filter
- ❑ Flipping selections
- ❑ Eraser
- ❑ Text work paths
- ❑ Paragraph settings
- ❑ Plastic filter
- ❑ Brush tip design

REQUIREMENTS

- ❑ None

RESULT

- ❑ A diploma celebrating your completion of the projects in Project: Photoshop

PROCEDURES

1. Design a corner flourish
2. Copy to other corners
3. Flatten and clean up
4. Make fancy paper
5. Pathify yourself
6. Stroke yourself
7. Add your accomplishment
8. Make a seal
9. Shine the seal

PROCEDURE 1: DESIGN A CORNER FLOURISH

1. In Photoshop, create a new image that has a **Height** of **7.5 inches,** a **Width** of **10 inches,** a resolution of **200 pixels/inch** if your computer has at least 96 megabytes of memory (**72 pixels/inch** if your computer has less), in **RGB Mode,** with a **White Contents.**

2. Create a new layer.

3. Set the foreground color to black and the background color to white.

4. Select the **Pencil** tool.

5. Open the **Brushes** palette, click **Brush Tip Shape**, and select any of the hard round brushes.

6. Choose the **Spacing** option and set the spacing value to **200%.** If you're working with the 200 pixels/inch resolution, set **Diameter** to **65 px.** Otherwise, choose **19 px.**

7. Using the method seen in Project 17, Procedure 4, make the brush size **Fade** in **5** steps (do not set up a color fade).

8. Point to a spot one-half inch down from the top of the image, and one-half inch in from the left. Press down the mouse button then press down the shift key and drag slowly to the right. A straight series of separated shrinking dots appears. Stop when the sixth dot appears.

9. Repeat step 7 (even starting at the same spot), only dragging down instead of to the right.

 Do *not* hold down the shift key before you press the mouse button. If you do that, Photoshop thinks that you want to draw a straight line starting where your last drag ended and ending at your current pointer location.

PROCEDURE 2: COPY TO OTHER CORNERS

1. On the brushes palette clear the **Shape Dynamics** check box to turn off the size fade effect.

2. Paint a dot into the extreme upper right-hand corner of the layer, and another into the lower left-hand corner. Don't worry that part of the brush is beyond the image border; just make certain that those corner pixels are painted.

 You're about to do some commands that flip a rectangular area containing the visible portions of the layer. If you didn't have these dots, the corner pattern you made would flip but stay in the upper left. With these dots in place, Photoshop sees the whole layer as being part of the visible portion.

3. Go to the layers palette and drag this layer's entry onto the **Create a New Layer** button. A new copy of this layer appears.

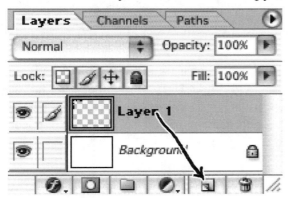

4. From the **Edit** menu, choose **Transform, Flip Horizontal.** The copied layer becomes a mirror image of the original, putting the corner pattern into the upper right corner.

5. Copy this layer using the technique shown in step 3.

6. From the **Edit** menu, choose **Transform, Flip Vertical.** This layer now has the corner pattern in the lower right.

7. Repeat steps 3 and 4 to copy the layer with the lower-right pattern and place the pattern in the lower left.

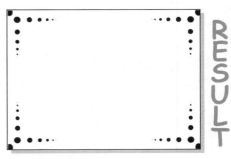

RESULT

PROCEDURE 3: FLATTEN AND CLEAN UP

1. From the **Layer** menu, choose **Flatten Image.** The dot patterns and corner dots from all of the layers are combined into the background.

2. Choose the **Eraser** tool (shortcut: **e**) from the toolbox.

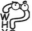 If you're drawing with a tablet rather than a mouse, you may not have to reach for this tool. Instead, flip your stylus upside down. Most modern tablets treat the butt end of the stylus as an eraser, automatically selecting Photoshop's eraser tool when you drag with it.

3. Click the **Brush** drop menu on the option bar, choose a hard round brush, and set the **master diameter** to a little larger than the pencil brush you used.

 Soft brushes are fine when you want to lighten something or to smooth away an edge. If you want to eliminate something, use a hard brush.

4. Use the eraser to erase the corner dots.

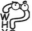 You may have trouble seeing into the upper-left corner because Photoshop has a little symbol with the number 01 displayed there. If so, go to the **View** menu and choose **Show, Slices.** That little extra (which is used to show which number slice of your image this is—handy when you're slicing your image but not needed in most cases) disappears.

PROCEDURE 4: MAKE FANCY PAPER

1. Set the foreground color to a rust color and the background color to a cream color.

 I suggest trying a foreground with an **R** value of **158**, a **G** value of **28**, and a **B** value of **32**. For the background, try settings of **255, 247**, and **201**, respectively.

2. From the **Filter** menu, choose **Sketch, Note Paper.** A dialog box appears.

3. Set **Image Balance** to **26, Graininess** to **13**, and **Relief** to **5**.

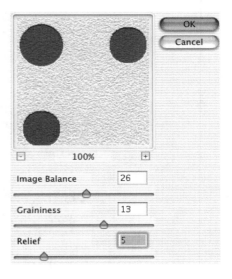

4. Click **OK.** The white areas of the image become cream-colored notepaper. The black dots of the corner pattern now look like holes burned into the paper, revealing red construction paper beneath.

 If you like this design and want to reuse it on other things, save the file now!

A DEEPER UNDERSTANDING: NOT UNDERSTANDING DEPTH

I just described the red dots as looking burned into the paper, but you might see them as raised off the paper, like glued-on pieces of construction paper. Is one of us wrong? Nope.

In various filters, Photoshop creates the illusion of depth by brightening one edge of an object and darkening another. The dark edge at the top of the dots could be shadows cast by raised dots lit from below the image or shadows being cast into a cut lit from the top of the image. Because we're looking straight at the dot/cut, rather than from an angle, there's no shaping to the shadow to tell us which direction is right. And because we're dealing with an image that's actually flat, rather than a 3-D projection, the natural depth perception that comes from having two eyes won't help at all.

RESULT

PROCEDURE 5: PATHIFY YOURSELF

1. Get the **Type** tool, reset it, and set **Font** to **Times New Roman, Style** to **Italic, Size** to **72 pt.**

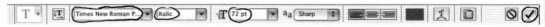

2. Type your name in the middle of the image.

3. Click the check mark at the end of the option bar to show you're done typing.

4. From the **Layer** menu, choose **Type, Create Work Path.**

5. On the **Layer** menu, choose **Delete, Layer.**

 You only created this type layer as a step toward creating your work path. You'll be using that work path to create a fancier version of the text.

6. A dialog box appears asking you to verify this action. Click **Yes.**

• •

A DEEPER UNDERSTANDING: FONT SIZE

You may have noticed that I specified a font size of 72 without mentioning a different size for people working at different resolutions. This is because Photoshop doesn't measure font size in pixels. Font size is measured in *points* (abbreviated *pt*), each point being 1/72 of an inch. The measurement is the height of the total vertical space for letters, from the top of the capital letters on one line of text to the top of capital letters on the next line of text. The individual letters are actually shorter than the font size, so that there is space between lines of text. Therefore, 72 point text takes up 1 inch per line, no matter whether you're working at 72 pixels/inch or at 200.

ImageReady doesn't use point size measurements. It can't because it never tracks anything in inches. It doesn't even have image resolution. ImageReady tracks everything in pixel measurements, including fonts.

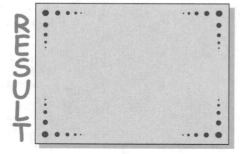

PROCEDURE 6: STROKE YOURSELF

1. Set the foreground color to black.

2. Choose the **Pencil** tool (shortcut: **b**) and open the **Brushes** palette. Click **Brush Tip Shape** and choose a hard round brush.

3. If you're working at 72 pixels/inch, set **Diameter** to **7** pixels. If you're working at 200 pixels/inch, use **20** pixels instead.

4. Set **Spacing** on, with a value of **25%.**

5. Drag the arrow on the circular brush design counterclockwise, rotating the brush design about one eighth of the way around.

6. Drag one of the brush shape's roundness handles toward the center of the design until it touches the other roundness handle. The brush field on the option bar shows an image of the current brush tip.

7. Click the **Stroke path with brush** button on the paths palette. Your name gets stroked with the selected brush.

8. On the paths palette, drag the work path to the trash can icon.

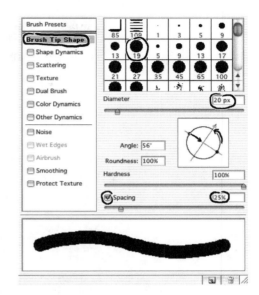

PROCEDURE 7: ADD YOUR ACCOMPLISHMENT

1. Get the **Type** tool again, and set the **Size** to **36 pt.**

2. Drag a rectangle that starts from just below and inside the upper-left dot of the upper-left-corner pattern and ends just above your name and just inside the upper-right-corner pattern.

3. Open the paragraph palette.

4. Click the **Justify last centered** button and clear the **Hyphenate** check box.

 The four justify options keep both edges of a paragraph even, increasing the spacing between letters to make shorter lines the same length as longer ones. They vary based on how they treat the bottom line of text.

5. Type **This certifies that all twenty projects in the book Project: Photoshop 7 have been properly completed by,** then check the check mark at the end of the option bar.

If you make mistakes, you can make corrections by clicking your cursor into place and using the **delete** or **backspace** key to delete errors just like a word processor.

6. Drag a similar rectangle below your name and type **who shall be accorded all appropriate rights, privileges, and peanut butter sandwiches.**

A DEEPER UNDERSTANDING: PARAGRAPH OPTIONS

Between the character palette and the paragraph palette, you have a lot of options that change how text flows. If you want extra spacing between lines, that setting is on the character palette; but if you want extra spacing between paragraphs, that setting is on the paragraph palette.

Also on the paragraph palette are settings to indent the first line of text or to indent an entire paragraph.

RESULT

This certifies that all twenty projects in the book Project: Photoshop 7 have been properly completed by

Nat Gertler

who shall be accorded all appropriate rights, privileges, and peanut butter sandwiches.

PROCEDURE 8: MAKE A SEAL

1. Set the foreground color to bright red.

2. Create a new layer.

3. Set the **Font** to **Arial Black** at **36 pt.**

4. Drag a text box in the lower-right corner, below the existing text and within the corner design and type **OK**.

5. Rotate the text 15 degrees, using the technique shown in Project 13, Procedure 7.

6. Duplicate the layer, then go to the **Layer** menu and choose **Type, Convert to Shape.**

 If you're duplicating by dragging the layer entry onto the **Create new layer** button, make sure you're dragging by the layer title and not by the clipping path thumbnail.

7. Select the **Polygon** tool (shortcut: **u**) from the toolbox, pick the **Shape layers** and **Exclude overlapping shape areas** options, and set **Sides** to **11.**

8. Click the **Geometry options** drop arrow. On the settings box that appears, put checks in all three check boxes and set **Indent sides by** to **20%.**

9. Point to the center between the letters O and K, then drag outward until the shape surrounds the letters with some margin.

 It may not be very clear what you've just done here. Because you used the option to exclude overlapping shape, this layer now has a seal shape with the OK cut out of it. The OK still looks filled in because you have another layer with just the OK. Why do this? Because you're going to do an effect on the surface that excludes the OK.

This certifies that all twenty projects in the book Project: Photoshop 7 have been properly completed by

Nat Gertler

who shall be accorded all appropriate rights, privileges, and peanut butter sandwiches.

RESULT

PROCEDURE 9: SHINE THE SEAL

1. From the **Layer** menu, choose **Layer Style, Satin.** A dialog box appears.

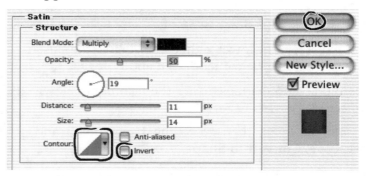

2. From the **Contour** drop list, choose **Linear,** (the one with the flat angle). Clear the **Invert** check box then click **OK.**

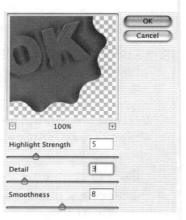

3. On the layer palette, link the two OK layers together.

4. From the **Layer** menu, choose **Merge Linked** to turn the two OK layers and the satin effect into a single raster layer.

5. From the **Filter** menu, choose **Artistic, Plastic Wrap.** (I never thought of plastic wrap as *artistic* before, did you?) If you're asked if you would like to rasterize the shape, click **Yes.** A dialog box appears.

6. Set the **Highlight Strength** to **5,** the **Detail** to **3,** and the **Smoothness** to **8,** then click **OK.** The seal takes on a shiny appearance like a stamped wax seal.

7. Save your image, print your image, sell your image to foreign spies, or do whatever else you want with it. You're done!

RESULT

This certifies that all twenty projects in the book Project: Photoshop 7 have been properly completed by

Nat Gertler

who shall be accorded all appropriate rights, privileges, and peanut butter sandwiches.